Hayley Lever

(1876–1958)

February 20–April 5, 2003

Carol Lowrey

Preface by
Marte Previti

Spanierman Gallery, LLC

www.spanierman.com

45 East 58th Street New York, NY 10022
Tel (212) 832-0208 Fax (212) 832-8114 monica@spanierman.com

COVER:

The Port of St. Ives, Cornwall, England (detail of Cat. 10)

Published in the United States of America in 2002 by
Spanierman Gallery, LLC, 45 East 58th Street, New York, NY 10022.

Copyright © 2003 Spanierman Gallery, LLC.

Library of Congress Control Number: 2002116246

ISBN 0-945936-56-7

Design: Marcus Ratliff
Photography: Roz Akin
Composition: Amy Pyle
Color imaging: Center Page
Lithography: Meridian Printing

Acknowledgments

On viewing the present exhibition, it is evident that Hayley Lever's paintings are marked by a singular energy and vibrancy. Yet, despite his bold technique and even the recent appreciation of his works in the marketplace, Lever has never been honored by a serious retrospective. Thus, it is with great pleasure that Spanierman Gallery, LLC presents *Hayley Lever (1876–1958)*, which will be the most scholarly and comprehensive exhibition of Lever's works to date. It is our hope to reintroduce this truly unique artist to the public and give his work the attention it deserves.

We thank all of our lenders, whose generosity has greatly enhanced this exhibition. These include CIGNA Museum and Art Collection, Philadelphia; Sandi and Bob Durell; Thomas L. Phillips; Matthew M. Vaccaro and Donna A. Salvatore; and Dr. and Mrs. Bernard H. Wittenberg.

We would like to recognize the efforts of all members of the Spanierman Gallery staff, especially those of Roz Akin, Bill Fiddler, Amy LaPlaca, Erica Meyer, Lisa N. Peters, Inbal Samin, Deborah Spanierman, and Christina Vassallo. A special mention must go to Carol Lowrey, author of the catalogue, for her thorough scholarship and her steadfast determination in completing this project under considerable time constraints. As always, we are grateful to Marcus Ratliff, our catalogue designer, and his associate Amy Pyle.

Also, we would like to extend our sincere appreciation to Mary Liberatore and Marte Previti. Not only have they provided us with extensive information on Lever and his oeuvre, but their passionate lifelong commitment to his work has been an inspiration to all of us during the preparation of this exhibition.

Ira Spanierman and Monica Heslington

Research Acknowledgments

I would like to thank Mary Liberatore of the Clayton-Liberatore Gallery for graciously allowing me access to Richard Hayley Lever's Publicity Book. I would also like to express my gratitude to Janet Axten of the St. Ives Archive Study Centre for her invaluable assistance in identifying the sites in Lever's St. Ives's pictures. Other individuals who provided help with sources, information, and photographs include: Celeste Badilla; Cape Ann Historical Museum, Gloucester, Massachusetts; David Cornish, development officer, Prince Alfred College, Adelaide, Australia; David Dearinger, chief curator, National Academy of Design, New York; John Driscoll, Queen's Historical Society; Linda Freaney, Woodstock Artists Association, Inc., New York; William H. Gerdts; Historical Society of Western Pennsylvania, Pittsburgh; Walter C. Kidney, Pittsburgh History & Landmarks Commission; Frederick Lewis, Belleville Public Library, New Jersey; Lynette Madelin, Exmouth Library, Exmouth, England; David Messum and Corinna Wain, David Messum Fine Art Limited, London; Marte Previti; Rockport Art Association, Massachusetts; Jonathan Thomson; John McWilliams, St. Ives Archive Study Centre, Cornwall; Joe Van Nostrand New York County Clerk's Office; and Marion Whybrow.

At Spanierman Gallery, research assistant Christina Vassallo provided key support in terms of document retrieval and related research matters. I would also like to acknowledge the encouragement and assistance of Lisa N. Peters, director of research and Sandra Feldman, research associate. Thanks should also be extended to Carolyn Lane, an independent scholar who spent considerable time gathering information for our Lever research files.

Carol Lowrey

Preface

In the fall of 1911, when I was born in the unsavory New York City neighborhood of Hell's Kitchen, a young artist across the Atlantic was preparing himself for a momentous career move, immigrating to the same city in search of fame and fortune. Only a clairvoyant might have ventured to predict that these two individuals, who never met in person, would become inextricably entangled posthumously via the muse of art.

Although I received a degree in chemical engineering from the Cooper Union in 1932 and was involved in the chemical field for most of my career, art in its various forms has always been part of my life. In 1934 my employer, Allied Chemical Corporation, posted me to its branch office in Buenos Aires, Argentina, where I became an amateur photographer in my spare time, an avocation that I still practice in my ninety-second year. During those sixty-eight years of picture taking—mostly black-and-white images—I have received numerous awards, had my photographs published in many newspapers, and held exhibitions in galleries, museums, and universities, in both the United States and South America.

Photography was not enough for me, however. After studying art conservation at the Institute of Fine Arts, New York University, I opened a gallery specializing in nineteenth- and twentieth-century American art. It has been a great learning experience. The excitement of having a wonderful and historic masterpiece pass briefly through the gallery on its way to the wall of a happy collector made up for the occasional disappointment when what promised to be a great find turned out to have little value.

In 1985 we were offered at an attractive price the remaining inventory of a closed dealership, consisting of a collection of more than seventy paintings by Hayley Lever. After researching the market for Lever's work, I and my wife and partner, the operatic soprano Elisabeth Carron, made the investment. That was the beginning of my involvement with this émigré artist. While preparing the collection for a retrospective exhibition and sale held that year, I became thoroughly steeped in Lever's background and career. I admired him for his perseverance, for the exuberance in his art, for his endless creativity and originality, and for producing images that leapt from the canvas with their energy and vigor. Seeing a turbulent Lever seascape for the first time is a sensuous experience for me.

Our exhibition in 1985 was a success and increased my interest in Lever's career. It also resulted in a flood of offers of his works from disparate locations around the country—evidence of his popularity when he was at the peak of his productive years. Lever was so prolific that I eventually collected records of more than two thousand paintings from catalogues, auction sales, and collec-

tions, including all the major American art museums. It troubled me that such a fine artist, whose integrity and devotion to his art were indisputable, had not yet received his well-deserved recognition. I decided to try to rectify this lapse by assembling the clear-cut evidence for such a judgment in the form of a catalogue raisonné.

The painting *Allegheny River, Pittsburgh* (Cat. 22), in this exhibition, is a poignant reminder of the difficult decisions that Lever faced during his career. Painted in the 1920s, this work remained unsold in the racks of the Clayton-Liberatore Gallery in New York until the Mellon family expressed an interest in it in 1954. The painting was offered at $2,500, and Clayton shipped it to Pittsburgh for inspection on February 9, 1954. A letter dated March 24, 1954, from Mr. A. W. Schmidt of T. Mellon & Sons indicates that the painting was rejected because it portrays the industrial hub in all its glory, depicting smoke and fumes spewing from every conceivable source—factories, boats, and railroad trains. Since the city had passed Smoke Control ordinances in 1946 and was relatively pollution free by this time, the Mellons were shocked to see this depiction of the bad old days, having expected to see a bright and cheerful scene to hang in their offices. The Carnegie Institute refused to accept it for its permanent collection, even for historical purposes. Obviously, the community was in denial mode. The stipulation was that the painting would be acceptable if Lever would remove the offending fumes from it. His reply, "Never!"

When Lever's career was at its lowest, and the major galleries had abandoned him, the Clayton-Liberatore Gallery remained loyal, continuing to sell his work to a number of faithful collectors. After Leonard Clayton died, his niece Mary Liberatore inherited the business and is still active in its affairs at the age of ninety. I am greatly indebted to her for much of the information and documentation about Lever.

In closing, I quote another Lever conviction: "Honest work, honestly done, will some time be appreciated and understood." There can be no doubt that today, after decades of neglect, Richard Hayley Lever has regained his stature as a major artist of the first half of the twentieth century in this country and deserves the attention he now enjoys from knowledgeable collectors.

Marte Previti

Richard Hayley Lever: Artist of Individuality

It is always a blessed relief to find an artist who has the courage not to be ashamed of his own individuality, and to face the world as himself, not as a member of some group or other. Meeting such a man in our day is like stepping out of a subway crush into a green and quiet place where a lone shepherd plays the Pan pipes under the trees.

I always think of something like that when I look at the work of Hayley Lever. In all his painting, whether it is of boats dancing on the waters of the Cornish coast, the ferry bridges and boats and streets of Gloucester, Massachusetts, the steaming asphalt highways of New York City, or the gently upheaving Catskills about Woodstock, it is always Lever who addresses us.

—Edgar Holger Cahill (1922)[1]

Hayley Lever . . . is one of the freshest and most vigorous painters who are still allied with the Academy. He does not depend upon stale academic recipes but prefers to see and paint things in his own way . . . his work shows an invigoratingly personal point of view.

—Lloyd Goodrich (1929)[2]

CAHILL'S AND GOODRICH'S words are telling, for they underscore the esteem in which this talented émigré artist (Fig. 1) was held during the early twentieth century and the way in which many American critics perceived his work. Indeed, after establishing a notable presence in British art circles at the turn of the century, the Australian-born Lever was encouraged to take up residence in the United States. He accepted the challenge and, settling in New York in 1912, made a name for himself on the national art scene, winning awards and honors in the leading annuals, enjoying solo exhibitions at public and commercial galleries, and attracting accolades from a host of critics who applauded his modernity, the diversity of his subject matter, and his artistic autonomy. By the early 1920s his oils had found their way into major public collections in New York, Washington, D.C., Detroit, Dallas, Los Angeles, and elsewhere, and his patrons included such influential figures as Duncan Phillips.

Yet despite his unqualified success, Lever's name is conspicuously absent from the standard textbooks on American art, as well as from the majority of studies dealing with the history of American Impressionism and Post-Impressionism. His name does crop up in publications devoted to artistic activity in St. Ives, Cornwall, and Cape Ann, Massachusetts, but for the most part he remains

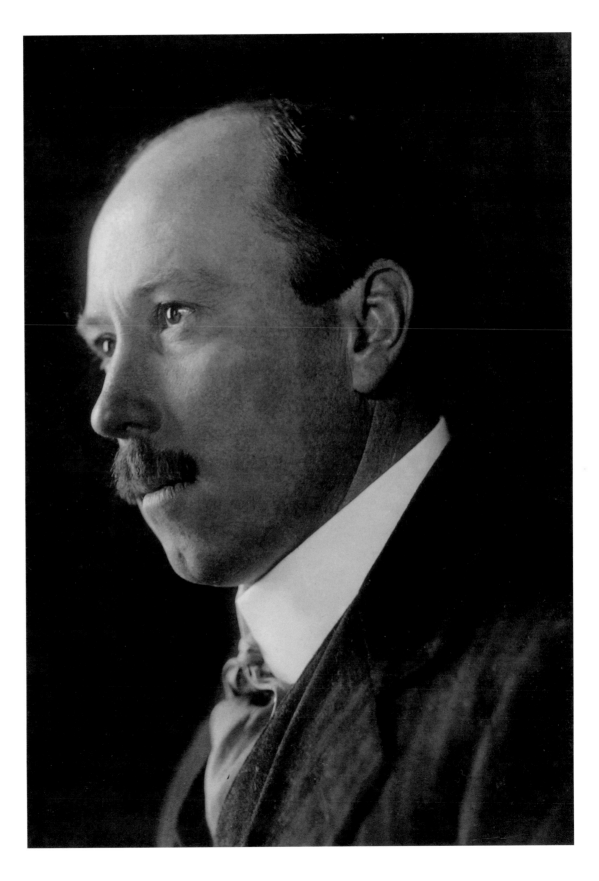

Fig. 1.
Portrait of Hayley Lever,
ca. 1920. Photographs of
artists—Collection I,
Archives of American
Art, Smithsonian Institu-
tion, Washington, D.C.

something of an enigma to contemporary art audiences in the United States—an under appreciated artist whose work has nonetheless been promoted by a coterie of dedicated dealers and acquired by a number of discerning collectors. To be sure, it is probably because he chose to exert his artistic independence—refusing to ally himself with any particular school or ism—that accounts for his absence in much of the literature devoted to early twentieth-century American art. It is the intention of this text and the accompanying catalogue entries to broaden aspects of Lever's biography and, most importantly, to highlight his principal thematic interests and explore his critical reception in American art circles of his day.[3]

Lever's Early and Formative Years

Throughout his career, Lever portrayed a variety of subjects, from landscapes and urban scenes to still lifes. However, he was first and foremost a painter of boats and the sea. That marine painting should be his favorite pursuit is not at all surprising, for Lever received his earliest artistic training from James Ashton (1859–1935), an English-born painter of seascapes, while attending Adelaide's Prince Alfred College (Fig. 2) from 1883 to 1891.[4] As the school's drawing master, Ashton taught Lever the rudiments of draftsmanship, instilling in him a respect for drawing, a penchant for careful observation, and a love of line that would inform his art for the rest of his career. He also sparked his student's interest in

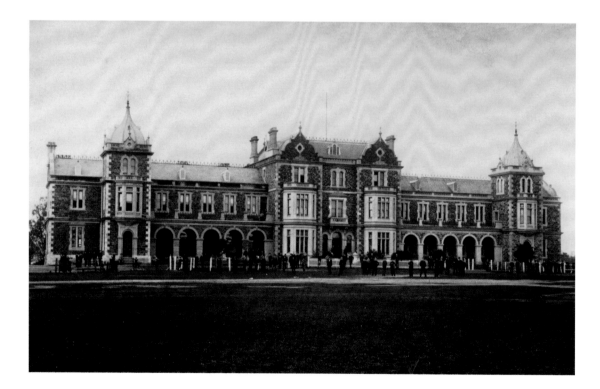

Fig. 2.
Prince Alfred College, Adelaide, South Australia, photograph courtesy of Prince Alfred College, Adelaide, South Australia.

depicting the sea, especially during 1891–93, when Lever, having graduated from Prince Alfred College, attended Ashton's Academy of Arts in Adelaide. Details relative to Lever's activities and influences during this period are scarce, but we know that when he was not in the classroom he was painting and sketching in the countryside outside of Adelaide. His sympathetic grandmother (on his mother's side) also set aside a room in her house in which he could paint.

Like most Australian artists of his generation, Lever ultimately left his homeland for further study abroad, although the paucity of correspondence and primary source material make an exact reconstruction of these formative years difficult. About 1894—and perhaps as late as 1899—he traveled to London to study art, funded in this endeavor by an inheritance he received from his maternal grandfather, Richard Hayley.[5] Whether Lever enrolled in any of London's art schools remains a mystery, and on later biographical questionnaires, he simply stated that he had "studied" in England's capital.

Lever presumably spent some of his time visiting commercial and public galleries, familiarizing himself with the art of both past and present. In her book *Art and Artists of New Jersey*, Lolita Flockhart recounts that he had specifically mentioned a trip to the National Gallery, where he saw works by the early Renaissance painter Piero della Francesca and came away deeply impressed by that artist's handling of color, design and composition.[6] He would also have seen examples of late nineteenth-century British art, which had evolved from its earlier emphasis on anecdotal figure and genre painting to more avant-garde forms, notably pleinairism and Impressionism, the latter emphasizing landscape subjects and the portrayal of modern life. Work in this vein could be seen at the New English Art Club (established 1886), whose members included the London Impressionists Walter Sickert and Philip Wilson Steer, and at the Royal Academy, which began to show examples of British Impressionist landscape painting in the 1890s.[7] Examples of French Impressionism could also be found at London galleries, such as those of Durand-Ruel and occasionally at the New English Art Club, and certainly, Lever's praise of exponents of the "new painting," such as Alfred Sisley, Camille Pissarro, Claude Monet, and Edouard Manet, confirms his exposure to their work.[8]

At some point around the turn of the century, Lever spent two winters in Paris studying the figure, presumably with the painter René-François-Xavier Prinet (1861–1946), one of three artists Lever lists as having been his teachers on a biographical card he filled out for the National Academy of Design.[9] The other two instructors Lever mentions on this document were the British Impressionists Julius Olsson (1864–1942) and Algernon Talmage (1871–1939), who were among the principal members of the artists' colony in St. Ives.

Indeed, about 1899—on the advice of James Ashton—Lever left London and went to St. Ives, an ancient fishing port on England's Cornish seacoast. It was also a thriving cosmopolitan art colony—the English analogue to Concarneau, the popular artists' haunt in Brittany, France.[10] That painters should be lured to St. Ives is understandable, for it proffered sandy beaches (four in all), dramatic

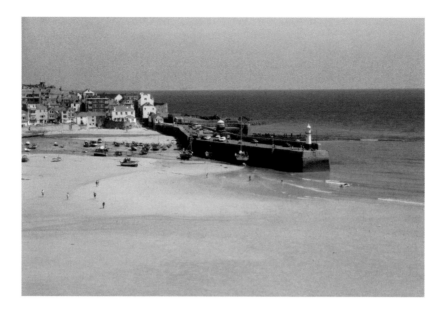

cliffs, winding streets with old-fashioned cottages, a temperate climate with clear, translucent light, and a lively waterfront replete with stone quays (Fig. 3) and all types of fishing boats (Fig. 4–5). Affordable accommodations were also available in the form of rented net lofts in Downalong, the area of the old town bordering the waterfront that was home to St. Ives's hard-working fishermen and their families.

British artists such as J. M. W. Turner had been going to the Cornish peninsula since the early 1800s, but the late-nineteenth-century vogue for outdoor painting made it a natural gathering place for devotees of pleinairism. Indeed, St. Ives began to emerge as an artists' center during the mid-to-late 1880s, attracting visitors such as James McNeill Whistler, who went there with his

Fig. 4.
Smeaton's Pier with
Luggers, ca. 1900,
photograph courtesy
of St. Ives Museum,
Cornwall.

Fig. 5.
Parish Church and
West Pier, St. Ives,
ca. 1900, photograph
courtesy of St. Ives
Museum, Cornwall.

students Mortimer Menpes and Walter Sickert. Whereas the neighboring art colony of Newlyn, about ten miles away on the south side of the peninsula, was populated by such well-established British figure painters as Stanhope Forbes and his wife, Elizabeth, St. Ives became a haven for marine and landscape painters, appealing to native-born artists such Olsson, Talmage, Alfred East, Adrian Stokes, and other painters whose aesthetic proclivities revolved around the portrayal of light and air. For the most part, these artists worked in a fluid, atmospheric style that had its antecedents in John Constable's open-air land-scapes and in the work of the French Barbizon School, Whistler, and French Naturalist painters such as Jules Bastien-Lepage.[11]

The divergence in thematic concerns between the two communities was duly observed by one Harold Begbie, who declared, "Newlyn paints interiors, St. Ives nature. The men of St. Ives are all devoted to ocean, plain and rolling down. They work to catch the effect of sunlight on sea. They are outdoor men."[12] The critic and writer Charles Lewis Hind also commented on the differences between the artists in Newlyn and St. Ives, remarking that the former was pop-ulated by "veterans, men who have won their spurs," while the latter possessed "a Bohemian camaraderie that the sister colony lacks" and tended to appeal to the more "alert, sanguine, bright-eyed young men who are strenuously work-ing their way towards the front."[13]

Canadian, Scandinavian, Russian, Italian, German and French artists also gravitated to St. Ives, as did a number of Australians, including the marine painter Louis Munro Grier, as well as Lever and Will Ashton (James Ashton's son and Lever's former schoolmate in Adelaide).[14] By the time Lever arrived in St. Ives, the town had become a gathering place for American painters too. The earliest American to establish himself in the colony was the Massachusetts-born Impressionist Edward Simmons, who went there in the spring or summer

of 1886 and was so enthused about his surroundings that he touted St. Ives to his friend and fellow painter Howard Russell Butler, who at the time was residing in France. After seeing some photographs and listening to Simmons's accolades about the place, Butler decided to abandoned his plans to summer in Honfleur in favor of the Cornish seaport. Writing to a relative in the United States shortly after his arrival in Cornwall, he lauded the artistic attractions of Brittany and Normandy but had become convinced that "the French coast cannot boast of a single spot as beautiful as St. Ives. Here the water is pure and clear as crystal. The old town is fully as picturesque as Honfleur; the fisherman are splendid models; the coast is rugged and the sea heavy. Color exceedingly rich."[15]

In the summer of 1886, the American contingent in St. Ives consisted of Butler (Fig. 6), Simmons and his wife, the Boston painter Frank Chadwick and his wife, Emma, and the painter Harry Robinson and his wife.[16] Butler returned to St. Ives one year later, noting that the population of artists had "doubled" and "the fame of the place had spread."[17] Indeed, in the ensuing years and continuing until World War I, St. Ives was a seasonal haven for dozens of American painters, among them Paul Dougherty, Walter Elmer Schofield, and George Gardner Symons—all of whom would become friendly with Lever, encouraging him in his eventual expatriation to the United States.[18]

Lever and St. Ives

Mr. Lever's special study has been scenes along the southwest coast of England— Cornwall and Devon—and in particular the town and harbor of St. Ives. This region has rarely if ever had so good an interpreter. Mr. Lever has succeeded where many have failed, in giving its peculiar color and atmosphere, and that more elusive quality, its personality.

—Exhibition of Paintings by Mr. Hayley Lever of Cornwall, England (1914)[19]

Accounts of the St. Ives art colony at the turn of the century indicate that Lever enjoyed a lively social life there, fraternizing with fellow artists at The Sloop Inn, a popular pub, at Lanham's Gallery, which promoted the work of local and regional painters, and at the St. Ives Arts Club (established 1890), which he first visited in November 1900 and where he eventually became a member.[20] The spirit of camaraderie Lever enjoyed in St. Ives also extended to the cricket field, as sporting activities formed a significant part of the communal life of the artists: painters from St. Ives would frequently engage in matches with their Newlyn counterparts, among them Lever, who played on The Artists' Eleven during the early 1900s, his teammates including Olsson, Talmage, and his old friend from Australia, Will Ashton.

However, Lever's primary pursuit in St. Ives was painting. Following his arrival in the colony, he honed his skills as a pleinairist under the tutelage of Olsson[21] and Talmage, who operated the Cornish School of Landscape, Figure and Sea Painting out of the Harbour Studio (Fig. 7).[22] Theirs was a liberal institution (established 1895), which offered some studio instruction along with outdoor summer classes, augmented by the occasional sketching excursion to coastal France. An eager pupil, Lever painted constantly—"when the tide was out and when it was in, at all hours; sunrise, midday, sunset and moonlight"— receiving advice and critiques from his teachers.[23]

On perusing Lever's St. Ives work, it becomes apparent that both Olsson and Talmage exerted a marked influence on his early development. A painter of moonlit bays and stormy seascapes (Fig. 8), Olsson—who first visited St. Ives in 1890—seems to have set an especially strong example for Lever, inspiring the young artist's concern for nocturnal harbor seascapes. Talmage, whose forte was landscape painting, would surely have made an equally strong impression on Lever, for he was a devoted pleinairist who emphasized the importance of working outdoors. He was also active as an etcher, perhaps inspiring Lever's own excursions into that medium later in his career.

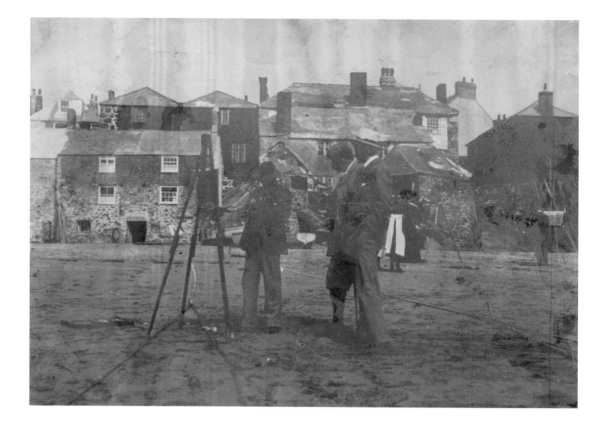

Fig. 7.
Hayley Lever, Julius Olsson, and Algernon Talmage, St. Ives, Cornwall, ca. 1900, photograph courtesy of Leonard Clayton Gallery, Incorporated and Clayton-Liberatore Gallery, Bridgehampton, New York.

Lever's years in St. Ives were highly prolific. He produced oils, watercolors (Fig. 9), and drawings, working outdoors as well as in his studio, located on the top floor of Lanham's Gallery. He later recalled his days in St. Ives, stating: "I really worked there. I did not quite realise then how much my future depended upon those days when I studied diligently from morning to night."[24]

During his St. Ives period, Lever depicted the sea, Smeaton's Quay, and the local harbor, and the surrounding countryside. Responding to the trend for moonlight effects that became so fashionable among St. Ives's artists, he painted many nighttime marines, a typical example being *Harbor by Moonlight, St. Ives* (Cat. 8), its fluid handling and somber palette paralleling aesthetic strategies espoused by the American Tonalists. However, adopting the free-thinking outlook that would characterize his aesthetic attitude for the remainder of his career, he also painted more colorful scenes, including small-scale, spontaneously rendered oil sketches, some depicting the port of St. Ives, others featuring views of London.

Lever went back to Australia in 1904, spending six months painting littoral subjects in Adelaide and Victor Harbor (Fig. 10), in addition to doing some teaching.[25] He arrived back in St. Ives in 1905, the *St. Ives Weekly Summary* noting: "Hayley Lever has just returned from an Australian voyage and will be in England for a few years to complete his studies."[26]

Fig. 8.
Julius Olsson
(1864–1942), *A Seascape by Moonlight,* oil on canvas, 24¼ × 30½ in., photograph courtesy of David Messum Fine Art Limited, London.

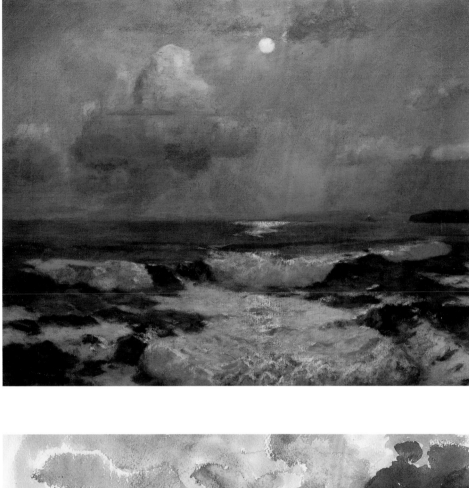

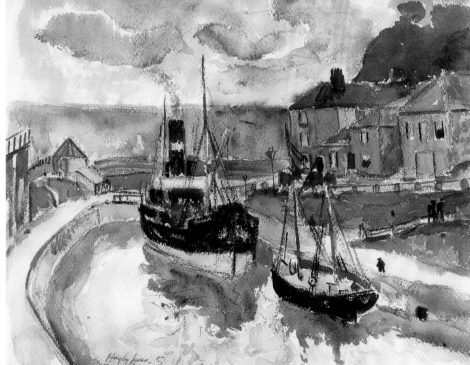

Fig. 9.
Hayley Lever, *Cornwall, England,* ca. 1900–10, watercolor on paper, Spanierman Gallery, LLC, New York.

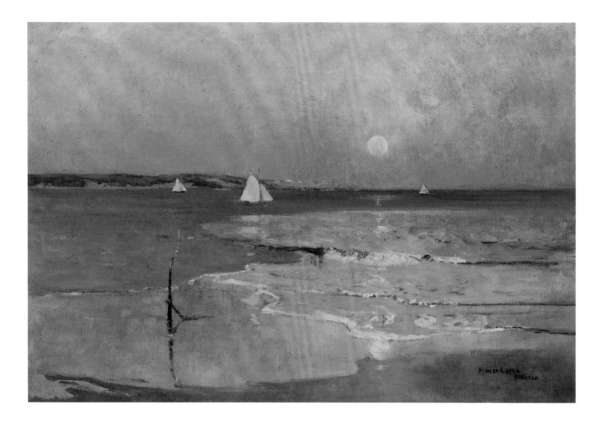

Fig. 10.
Hayley Lever, *Port Victor*, 1905, oil on canvas, 24 × 36¼ in., Ledger Gift, Benalla Art Gallery, Victoria, Australia.

Having resettled in St. Ives, Lever resumed his year-round pictorialization of the region, working in and around St. Ives as well as in Devon, Suffolk, and Kent. He also made trips to France, setting up his easel in such seaside locales as Concarneau, Dieppe, Honfleur, Douarnenez, Isle de Croix, as well as in Paris. It was around this time that Lever began working in an advanced Post-Impressionist manner that set him apart from his Cornish contemporaries.

An exact chronology for Lever's adoption of a more progressive painting style is difficult to determine; however, one major impetus likely involved his exposure to the work of Vincent van Gogh while on a trip to the Continent in 1908. Stimulated by the Dutchman's bold brushwork, vivid chromaticism, and emphasis on line and flat, two-dimensional form, Lever developed a bolder mode of painting, evident in a series of brilliantly colored paintings called *Van Gogh's Hospital, Holland*, in which he paid homage to the Dutchman and his aesthetic, and in St. Ives canvases such as *Landing Fish, St. Ives, Cornwall* (Cat. 9) and *The Port of St. Ives, Cornwall, England* (Cat. 10), with their characteristic complex designs, stylized shapes, and overt linearity. Lever's interest in simplified forms, rhythmic patterning, and dark, skeletel contour lines could also have been influenced by Japanese prints, which were much admired by artists in Paris and London. His fascination with Post-Impressionist precepts would have been given further impetus by such pivotal events as Roger Fry's exhibition *Manet and the Post-Impressionists*, held at the Grafton Galleries in London

in November 1910, a show that introduced the British public to modern European art as exemplified in the work of artists such as Van Gogh, Paul Cézanne and Paul Gauguin.[27]

Lever's paintings—especially his "unconventional" Post-Impressionist oils—were lauded in English and Continental art circles.[28] Throughout these years, he exhibited in provincial shows (including those of the St. Ives Art Club), in London—at the Royal Academy, the Royal Society of British Artists, and the New English Art Club—and in Paris, Nice, and Venice. He likewise began to establish a presence in the United States. In 1910, Lever made his American debut at the Carnegie Institute's annual international exhibition—which showcased the best examples of contemporary American and European painting—exhibiting his *Port of St. Ives, Cornwall*, which hung prominently in "Position 1."

By early 1912 Lever had acquired a reputation as "an impressionist of daring resource and with an unusual gift for eloquent design. Until recently he showed a great deal at the Royal Society of British Artists, where his exhibits were always eagerly looked for."[29] During that same year the artist sent another "large canvas to Pittsburgh USA to be placed on the line without a jury"—further evidence of his growing stature in the international art community.[30] Indeed, Lever went to St. Ives when "everybody was talking about painting outdoors."[31] He left that scenic place a talented, up-and-coming artist whose name would soon be "associated . . . so indelibly with Cornwall and Saint Ives"[32] and who would quickly make his mark on "New York's 'Picture Lane.' "[33]

Lever in America

Lever last appeared at the annual exhibition of the St. Ives Art Club in April of 1912. Although a number of previous biographical accounts place him in Manhattan as early as 1911, he did not arrive in New York until the autumn of 1912, accompanied by his wife and son.[34] His decision to leave England to try his luck in America's art capital was undoubtedly spurred by his success at the Carnegie International exhibitions; his 1910 debut was followed by another victorious appearance in 1911, when he exhibited his *Great Western Railway Viaduct under Snow*, one of his best-known works.

In 1912 Lever was represented in Pittsburgh by another Cornish picture—*A Cornish Viaduct in Snow*. One year later, he exhibited his *East River, New York*, which won an Honorable Mention—a reminder that on arriving in the United States, Lever immediately turned his attention to his new environment, producing drawings, watercolors, and paintings of the parks, streets, bridges, and waterfront of Manhattan.

Realizing that his future lay in the New World, Lever decided to remain permanently in the United States, applying for citizenship papers in 1913 and acquiring a studio on West Sixty-fifth Street on the Upper West Side. By this point he was firmly settled within the local art scene, fraternizing with the

painter Ernest Lawson, an old acquaintance who in turn introduced him to such New York Realists as Robert Henri, John Sloan, and George Bellows. Lever was also friendly with the landscape painter George Gardner Symons—another contact from St. Ives—who, as a member of the Arts Committee at the National Arts Club, was no doubt responsible for Lever's election as an artist life member of that institution in 1913.[35] In keeping with his growing interest in New York City subjects, Lever submitted one of his early views of Manhattan—*Riverside Drive and Seventy-second Street* (Fig. 11)—as his diploma presentation to the club.

By 1914 it was clear that Lever's reputation was on the ascent. During that year his *Winter, St. Ives* won the National Academy of Design's prestigious Carnegie Prize. Painted in Lever's distinctive Post-Impressionist style, this view of beached fishing boats with fishermen's cottages in the background was widely praised by local critics for its vigor, originality and "fine sense of time and place, of line design and pattern."[36] The award established Lever's prominence in New York art circles, and his acceptance by the conservative jury of award at the National Academy marked, as one art historian has pointed out, "an unexpected progressive step by that institution."[37]

No doubt—in terms of contemporary picture-making—Lever's work represented a compromise that obviously satisfied his peers and the critics: his paintings were both progressive and robust, going beyond the delicate, "broken touch" of Impressionism and demonstrating many of the formal qualities associated with modernism.[38] And unlike the radical, at times unrecognizable, European work by Cubists, Fauvists, and other cutting-edge artists shown at

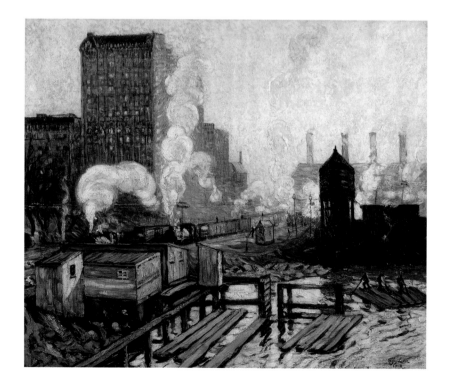

Fig. 11.
Hayley Lever, *Riverside Drive and Seventy-second Street*, 1913, oil on canvas, 30 × 36 in., National Arts Club Permanent Collection, New York, Diploma presentation, 1913.

the *International Exhibition of Modern Art* (Armory Show) in 1913, Lever's paintings were easily accessible to art audiences, portraying subject matter that was recognizable and highly appealing. Lever's eye-catching views of St. Ives were particularly attractive to critics and collectors who—unfamiliar with Cornwall and its environs—considered them highly exotic. Indeed, despite the advanced pictorial strategies demonstrated in his style, Lever's work was ultimately grounded in realism—the result of his desire to translate fact and natural phenomena into paint. As he stated: "The trees in a picture must be growing, the flowers blooming, the clouds flying, the moon rising, or the sun setting. The trees in most pictures would go over at the slightest breeze, but a real tree meets the wind with a rhythmic swaying."[39]

In 1914 Lever also had important one-man shows at the Memorial Art Gallery in Rochester and the Syracuse Museum of Fine Arts, each featuring St. Ives paintings, augmented by a group of recent New York pictures. The ninety works on display revealed, one commentator noted, "Direct and simple treatment, fine color, and extreme vitality characterize his works, and their vigor and sincerity make an irresistible appeal to the modern spirit."[40] The show was well received, a reviewer for a Rochester newspaper calling it a "revelation of beautiful paintings" exemplifying the most salient characteristics of Lever's art, in particular

> his color power and a certain calmness and sanity, which has no relationship to the commonplace, but which is rather allied to a high imaginative power that scorns mannerism and peculiarities and the particular methods and styles of various cults . . . His color is powerful and daring yet it never misses the more subtle harmonies of light and mist and water and trees and snow . . . If this seems over-enthusiastic praise, assurance may be taken from the fact that among artists he is considered one of the coming great artists, that in fact among them he has already 'arrived,' although to the public in America he is simply unknown for the present.[41]

As well as noting the large crowds who attended the opening of the exhibition in Syracuse, a local penman was equally effusive in his praise, observing that Lever

> paints in a broad way, and is what the artists regard as strictly up-to-date. His boats and water scenes are handled in a masterly fashion, and he possesses a faculty of depicting a happy combination of events. His sense of coloring is especially appealing. He has devoted much study to the English coast, and his canvases dealing with the town and harbor of St. Ives have seldom if ever been excelled as regards interpretation. . . . his pictures dealing with New York harbor are excellent specimens of true art.[42]

Lever received other awards and honors, including a gold medal at the National Arts Club in 1915. During that same year, he exhibited one of his St. Ives

harbor scenes in the American section of the *Panama-Pacific International Exposition* in San Francisco, adding another gold medal to his cache.

The year 1915 was also a crucial year for Lever in that he began exhibiting his work at the Macbeth Gallery, known for its long-standing commitment to promoting contemporary American art, where he would have a number of solo shows and participate in many group exhibitions. The year also marked a watershed for Lever in that he discovered the pictorial offerings of Gloucester, the famous fishing port and artists' colony on the Cape Ann peninsula of Massachusetts.

Indeed, Lever made his first visit to Gloucester in the summer of 1915 and was immediately struck by the fact that it so closely resembled his beloved Cornwall, with its charming cottages, narrow streets, and fishing boats. As well as conducting outdoor painting classes, he spent the summer painting watercolor views of the town and its harbor. Writing to Robert Macbeth in September, he declared: "I like the place. The people feel that I have struck a 'new idea' of Gloucester...You'll see for yourself."[43]

His dealer obviously liked what he saw, for Lever went on to exhibit his Gloucester scenes at Macbeth's gallery that October. He made regular visits to that venerable seaport in the ensuing years, making views of Cape Ann a vital part of his thematic repertoire. His trips to Gloucester also provided him with the opportunity to visit other port towns and resort spots in coastal Massachusetts, such as Nantucket, Marblehead, Annisquam, and Brant Rock, where, as always, he focused on depicting boats and the sea, alternating his stylistic approach in accordance with his subject, medium, and the mood or effect he wished to convey.

That Lever was considered an innovator in his field is evidenced by the various groups and galleries he exhibited with during the teens and twenties. Although his paintings were shown regularly at the national annuals in New York, Chicago, Philadelphia and Washington, D.C., Lever also allied himself with independent organizations such as the New Society of Artists, whose members included such esteemed painters as Robert Henri, John Sloan, and Rockwell Kent. Lever's stature as an artist with a personal vision is also affirmed by the fact that between 1916 and 1918, his work was featured at the Daniel Gallery in New York, which represented such vanguard painters as Maurice Prendergast, Samuel Halpert, and Marguerite Zorach. The Whitney Studio Club, which devoted its exhibition programming to groundbreaking American painting, also provided Lever another exhibition outlet.

Lever was at the height of his critical popularity during this period, winning favor from the likes of Charles Caffin who, noting that the artist had made an "immediate mark" in the art world, lauded his easel paintings for their "striking patterns of design" and commended him on his use of rhythmic lines to impart life and movement to his oils.[44] He was just as enchanted with Lever's watercolors, calling them "in the truest sense original; fresh with the novelty of a very personal motive, realized in a way entirely individual to the artist...[and

executed] with a freedom of handling that preserves to a remarkable degree the purity and brilliance of the medium."[45]

Lever's link with innovation and originality was also the subject of an article by Catherine Beach Ely. Writing in *Art in America* in 1921, she described him and his contemporaries, Ernest Lawson and William Glackens, as anti-academic painters who shared a love of conveying motion and who balanced their modernizing tendencies with a continuing emphasis on realism.[46] As well as remarking on Lever's talents as a colorist and draftsman and the feel and vigor he instilled in his work, she summed up his aesthetic approach as follows:

> Like other modernists he breaks away from scholasticism in Art and abjures the static; he makes a creed of motion … He admires the French impressionists—Renoir, Monet, Sisley and Pissarro: like them he believes in sincere, direct expression in art. His sympathies extend even to the extremely modern, yet his own work does not offend against beauty and good taste … His color and atmosphere are handled from the American viewpoint, yet in a way peculiar to himself.[47]

Critical interpretation of Lever as an nonconformist who followed his own path continued to flow from the pens of other critics, among them Edgar Holger Cahill, who admired the artist's ability to convey "the feeling of movement" and praised his talent for blending a diversity of sources "from the antique to the ultra-modern, not forgetting the Oriental," to make an original pictorial statement divorced from convention and the "fads of the moment."[48]

In addition, a writer for the *St. Ives Times* in 1924 stated: "Hayley Lever is really in advance of the times in his theory and practice of art—his work is an expression of the soul"[49] Two years later, he was among the artists included in Duncan Phillips's book *A Collection in the Making* (Phillips owned three of Lever's paintings), in which Lever was deemed a painter of "stately compositions" who deftly evoked the "animated effects of linear movement with old stone houses, steep and sinuous streets, populous wharves, sprightly sailboats and restless waters."[50] Although Phillips acknowledged that Lever's Gloucester subjects showed the same "zest for design" as his Cornish pictures, he felt that they lacked their romance of his English views—probably due to the fact that Gloucester, a favorite painting locale for so many American artists, had become a ubiquitous motif in the iconography of turn-of-the-century American painting.[51]

Lever continued to win awards and prizes well into 1930 and early 1940s, among them the National Academy of Design's Edwin Palmer Memorial Prize for marine painting (Cat. 35) at the 1938 annual. However, as was the case for other painters of his milieu, sales of his work were minimal due to the stock market crash and the subsequent economic constraints of the Depression. Lever was able to supplement his income with teaching, at the Art Students League and elsewhere; however, his financial state was constantly precarious. Archival records of the Macbeth and Milch galleries contain correspondence

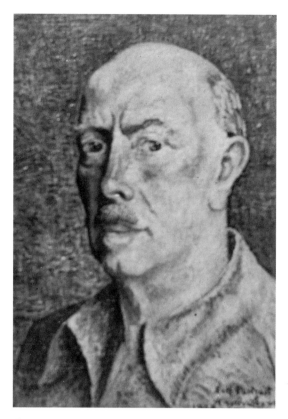

Fig. 12.
Hayley Lever, *Self-Portrait*, 1944, oil on board, location unknown, photograph from *Hayley Lever: Commemorative Exhibition*, exh. cat. (Bridgehampton, N.Y.: Clayton-Liberatore Gallery, 1969).

that indicates the severity of the situation for both Lever and his dealers. On one occasion, having asked the Milch Gallery for an advance, he was sent a letter telling him that no help would be forthcoming, as "our business has dropped down to almost nothing."[52] The Macbeth Gallery made continuous attempts to sell Lever's work (and that of other artists in its stable), but sales were sporadic, providing Lever with little income. Surviving letters from the 1930s includes one Lever wrote to Robert Macbeth in 1937, in which he expressed his disappointment that officials at the Corcoran Gallery, who had once regaled him with cards, invitations, and studio visits and who purchased one of his works, had neglected him; he was "Now forgotten by them it appears."[53]

About 1930 Lever left New York and moved to Caldwell, New Jersey. He remained there until 1938, when, due to continuing financial problems, he lost his home at 66 Ravine Avenue. He subsequently moved to Mount Vernon, New York, where he became director of the Studio Art Club. The various economic setbacks Lever experienced during these years had a direct effect on his art, resulting in a greater degree of expressivity in his style. His link with van Gogh was at its peak during this later period of his career (Cat. 38), when he turned frequently to a style characterized by thick, fluid brushwork and a strident chromaticism. Emotional resonance came to play a greater role too, evidenced by the brooding intensity of his self-portrait (Fig. 12) and in works such as *Approaching a Farm* (Cat. 37)—both of which exemplify Lever's oft-quoted dictum that "art is the re-creation of mood in line, form and color."[54] At the same time, eclecticism continued to define his art, which could take on overtones of American Scene painting (Cat. 32) or become so minimalist in its design as to verge on the abstract (Cat. 35).

Unfortunately, the expressive nature of much of Lever's later aesthetic did not sit well with the art-buying public or with many critics, one of whom, writing in 1945, felt that notwithstanding Lever's obvious technical skill, his work appeared "overwrought," the product of an "agitated spirit."[55] However, Lever continued to paint. When debilitating arthritis curtailed his seasonal trips after 1940, he devoted most of his time to still lifes—a theme he had taken up in the early 1900s—and learned to paint with his left hand. After spending several years at Crestview Hall, a nursing home in Mount Vernon, he died in the local hospital on the 6th of December 1958.

Certainly, early-twentieth-century critics were correct in their evaluation of Lever as a non-traditionalist and an artist of individuality. Although marine painting remained his forte, he was equally at home depicting landscapes, still lifes, and the urban environment. His work was influenced by Impressionism, with its emphasis on light, atmosphere, color, and mood, but, seeking to expand his means of creative expression, he extended his pictorial investigations well beyond that aesthetic, incorporating the decorative and coloristic concerns of Post-Impressionism into much of his work. Realism, Expressionism, and to some extent Abstraction touched his art as well, further reminders that Lever was an adaptable and versatile artist who kept an open mind when it came to his art. The legacy he left us—in his oils, watercolors, drawings, and etchings—is a testament to his maxim that

> It's not what an artist paints—it's how he paints it. Paintings may be abstract or realistic—it doesn't matter. The greatest art of all is great enough to cover any method . . . If there's enthusiasm in you, nothing on earth stops you. Painting is a joyful agony—a labor of love.[56]

Carol Lowrey

1. Edgar Holger Cahill, "Hayley Lever, Individualist," *Shadowland* 7 (November 1922): 11.

2. Lloyd Goodrich, "Exhibitions: The Milch Gallery," *Arts* 16 (30 June 1929): 265.

3. The most recent overview of Lever's career is Cheryl Kempler, *Hayley Lever: Works in Various Media,* exh. cat. (Wilmington, Del.: Delaware Art Museum, 1978).

4. David Cornish, development officer at Prince Alfred College, Adelaide, provided valuable information about Lever's schooldays, as well as biographical data on James Ashton. For an overview of Ashton's career, see Allan Sierp's entry on the artist in the *Australian Dictionary of Biography* 7 (Melbourne: Melbourne University Press, 1979), 109–10.

5. Accounts of Lever's career give varying dates as to his arrival in England, some stating that he went there in 1894, at the age of eighteen, others indicating a date of 1899.

6. "Hayley Lever, N.A., Caldwell, N.J.," in Lolita Flockhart, *Art and Artists of New Jersey* (Somerville, N.J.: C. P. Hoagland Co., 1938), 87–88.

7. For British Impressionism, see Laura Wortley, *British Impressionism: A Garden of Bright Images* (London: The Studio Fine Art Publications, 1988) and Kenneth McConkey and Anna Gruetzner Robins, *Impressionism in Britain*, exh. cat. (London: Barbican Art Gallery, 1995).

8. Helen Wright, "A Visit to Hayley Lever's Studio," *International Studio* 70 (May 1920): lxx.

9. Lever listed Olsson, Talmage, and Prinet, in that order. See Richard Hayley Lever file, National Academy of Design, New York. Prinet painted landscape, genre, and history subjects, as well as portraits. His American pupils included the Chicago Impressionist Pauline Palmer. Although Lever never specialized in figure painting, he did go on to teach life classes at the Art Students League in New York.

10. For the St. Ives art colony, see Denys Val Baker, *Britain's Art Colony by the Sea* (London: George Ronald, 1959), Michael Jacobs, *The Good and Simple Life: Artists Colonies in Europe and America* (Oxford, Eng.: Phaidon, 1985) and Marion Whybrow, *St. Ives, 1883–1993: Portrait of an Art Colony* (Woodbridge, Suffolk, Eng.: Antique Collectors' Club, 1994).

11. As noted by the English art critic, Charles Marriott, quoted in Baker, 30.

12. Harold Begbie, *The Morning Post*, quoted in Whybrow, 32.

13. Charles Lewis Hind quoted in Whybrow, 33.

14. Lever and Ashton, along with Hans Heysen and H. S. Power, were designated the four most "distinguished" artists to emerge from South Australia at the turn of the century. See William Moore, "The Public Art Galleries of Australia," *International Studio* 49 (May 1913): 212. Australian painters in St. Ives is the topic of a forthcoming M.Phil. thesis in art history by Jonathan Thomson, for the University of Hong Kong.

15. Howard Russell Butler to Mary M. Butler, 8 August 1886, Howard Russell Butler Papers, Archives of American Art, Smithsonian Institution, Washington, D.C., reel 1189, frame [illegible]. Butler did note one negative aspect to St. Ives—its "liability to sea-fogs."

16. See "Biographical Notes: Howard Russell Butler," 65, Butler Papers, reel 93, frame 175.

17. Butler also declared: "I understand that I am largely to blame for the increase in numbers," suggesting that he had touted the merits of St. Ives to his fellow artists back in Paris. See Howard Russell Butler to Harriet, 11 July 1887, Butler Papers, reel 1189, frame [illegible].

18. Dougherty and Symons visited St. Ives at the turn of the century, while Schofield settled there in 1902. Ernest Lawson is also named as one of the artists who suggested that Lever come to America. To date, I have not found any documentation that would confirm Lawson's presence in St. Ives. Other American artists in St. Ives during these years included Alexander Harrison and Frederick Waugh.

19. *Exhibition of Paintings by Mr. Hayley Lever of Cornwall, England*, exh. cat. (Rochester, N.Y.: Memorial Art Gallery, 1914), unpaginated.

20. Whybrow, 213.

21. For Olsson, see A. G. Folliott Stokes, "Julius Olsson, Painter of Seascapes," *Studio* 48 (1910): 274–82.

22. For Talmage, see A. G. Folliott Stokes, "The Landscape Painting of Mr. Algernon M. Talmage," *Studio* 42 (1908): 188–93, and by the same author, "Mr. Algernon Talmage's London Pictures," *Studio* 46 (1909): 23–30.

23. Wright, lxx.

24. "St. Ives in America," *St. Ives Times*, 19 September 1924, p. 10.

25. Ron Radford, *Our Country: Australian Federation Landscapes, 1900–1914*, exh. cat. (Adelaide: Art Gallery of South Australia, 2001), 164.

26. Quoted in Whybrow, 59.

27. The exhibit featured over twenty-four paintings and drawings by van Gogh. For a discussion of Modernism in Britain, see Anna Gruetzner Robins, *Modern Art in Britain, 1910-1940*, exh. cat. (London: Merrell Holberton Publishers in association with Barbican Art Gallery, 1997).

28. Quoted in Whybrow, 59.

29. "Studio-Talk," *Studio* 55 (15 February 1912): 47.

30. [Richard Hayley Lever to Adolph Albers], 1912, quoted in Whybrow, 60. The work Lever refers to is *A Cornish Viaduct and Snow.*

31. Flockhart, 87.

32. "In the Galleries." *International Studio* 57 (December 1915): 67.

33. "Lever and Davey at Gloucester," newspaper clipping [source illegible], 1915, Macbeth Gallery Papers, reel NMC2, frame 298.

34. According to the New York Naturalization Petition Index for 1907–24, Lever departed Liverpool on 21 September 1912, accompanied by his wife and son. They arrived in Boston eight days later and from there went to New York. I would like to acknowledge the diligent efforts of Sandra Feldman, research associate at Spanierman Gallery, who obtained this information (as well as data pertaining to Lever's date of citizenship—1921) from Joe Van Nostrand, senior management analyst at the New York County Clerk's Office. It should be noted that Lever's entry in the New York Naturalization Petition Index records gives 1875 as the year of his birth. In other documents, including dictionary entries, obituaries, and biographical questionnaires Lever later filled out for the National Academy of Design, his birthdate is indicated as 1876.

35. Symons and Ben Foster, another National Arts Club artist life member, acted as witnesses at Lever's citizenship hearing in 1921.

36. "The National Academy," *New York Post*, 19 December 1914, p. 9.

37. Oswald Rodriguez Roque, *Directions in American Painting*, exh. cat. (Pittsburgh: Museum of Art, Carnegie Institute, 1982), 48.

38. "American Modernity," unidentified newspaper clipping, 1915, Macbeth Galley Papers, reel NMC2, frame 297.

39. Richard Hayley Lever, quoted in Kempler, 6.

40. *Exhibition of Paintings by Mr. Hayley Lever of Cornwall, England,* unpaginated.

41. "Lever's Art Is a Revelation," *Post* (Rochester, N.Y.), [1914], Records of the National Arts Club, Archives of American Art, Smithsonian Institution, Washington, D.C., reel 4266, frame [illegible].

42. "Lever's Pictures Draw Art Lovers in Large Numbers," [unidentified newspaper clipping], Syracuse, N.Y., 6 November 1914, Records of the National Arts Club, reel 4266, frame [illegible].

43. Hayley Lever to Robert Macbeth, September 1915, Macbeth Gallery Papers, reel NMC59, frame 661.

44. Charles Caffin, "New and Important Things in Art: Remarkable Advance Shown in Hayley Lever's Recent Work," *New York American*, 19 March 1917, p. 7.

45. Caffin.

46. Catherine Beach Ely, "The Modern Tendency in Lawson, Lever and Glackens," *Art in America* (10 (December 1921): 31.

47. Ely, 32.

48. Cahill, 77.

49. "St. Ives in America," *St. Ives Times*, 19 September 1924, p. 10.

50. Duncan Phillips, *A Collection in the Making* (Washington, D.C.: Phillips Memorial Gallery, [1926]), 58–59.

51. Phillips.

52. [Albert Milch?] to Mr. Lever, 22 October 1931, Milch Gallery Papers, Archives of American Art, Smithsonian Institution, Washington, D.C., reel 4423, frame 11.

53. Hayley Lever to Robert Macbeth, January 1937, Macbeth Gallery Papers, reel NMC59, frame 697.

54. Hayley Lever quoted in "Paris in Jersey Found in Home of Caldwell Artist," *Newark Evening News*, 14 August 1936.

55. "The Passing Shows." *Art News* 44 (15 November 1945): 29–30.

56. Hayley Lever, quoted in Flockhart, 88.

1.

Moonlight, St. Ives, ca. 1900

Oil on board

9½ × 12 inches

Signed and inscribed lower right: *Hayley Lever / St. Ives*

After a period of activity in London, Lever went to St. Ives in Cornwall about 1899 to study with the British marine painters Julius Olsson and Algernon Talmage, avid proponents of plein-airism. Lever responded appropriately; indeed, he "studied years among the boats, 'when the tide was out and when it was in, at all hours; sunrise, midday, sunset and moonlight,'" recording his direct response to this picturesque locale in such paintings as *Moonlight, St. Ives.*[1]

Interpreted with soft, Whistlerian brushwork and a subdued gray-green and brownish palette, this modestly sized oil underscores the emphasis members of the local art colony put on "evening effects" and atmospheric "moonlights."[2] It also serves as a thematic precursor to Lever's later Post-Impressionist-inspired panoramas of St. Ives, among them the much more sharply-defined canvas, *The Port of St. Ives, Cornwall, England* (Cat. 10). Both works feature an open view of the old town, its skyline dominated by the majestic tower of the ancient Parish Church. Other landmarks of note appearing in each of the two images include West Pier and the local lifeboat house (to the right of the church). The Salvation Army Citadel, which is only partially shown in *The Port of St. Ives*, is portrayed here in its complete form on the far right, Lever's fluid, tonal handling and muted chromaticism giving it a moody, ethereal presence.[3]

1. Helen Wright, "A Visit to Hayley Lever's Studio," *International Studio* 70 (May 1920): lxx.

2. R. G., "A Letter from St. Ives, Cornwall," *Studio* 3 (1887): 55.

3. According to Janet Axten of the St. Ives Archive Study Centre, this structure was destroyed by fire in March 1915.

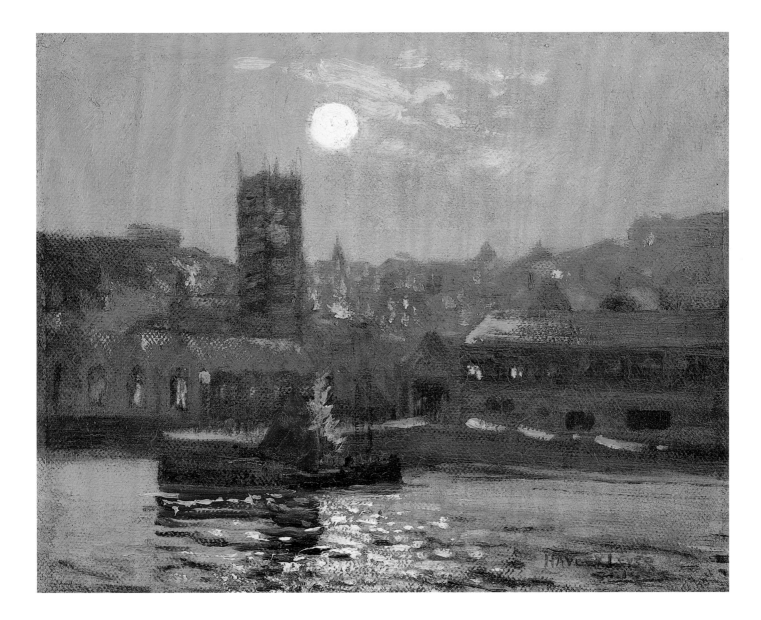

2.

Chelsea, England, ca. 1900–10

Oil on canvas
6½ × 9⅜ inches
Signed lower right: *Hayley Lever*

Lever's oeuvre includes many depictions of London, England, where he spent part of his early career. In addition to painting the more picturesque parts of the country's capital city, such as Kew Gardens and St. James's Park, he also depicted contemporary industrial life along the Thames, especially in the vicinity of Battersea and Chelsea, where one could still find gritty factories, warehouses, and crowded pubs, as well as river traffic in the form of barges and cargo ships.

Many of Lever's London scenes were done en plein air on modestly sized supports. Such is the case with *Chelsea, England*, which depicts the Thames as it flows through the borough of Chelsea. The artist describes the scene with broad brushwork, applying his pigments with thick strokes to create a lush, impastoed surface. The use of black contour lines—which became one of the trademarks of Lever's mature style—can be seen here, as well as his growing concern for stylized shapes, as in his portrayal of the clouds.

Lever synthesizes these approaches with a rich and varied palette, using browns, ocher, and black to render the buildings and waterfront; ivories, grays, and buff tones to evoke the muddy waters of the Thames; and pale purple to denote swirling plumes of smoke rising from the industrial buildings below. The occasional daub of bright red and touches of white add sparkling accents and act as a foil to the more somber hues of the architecture.

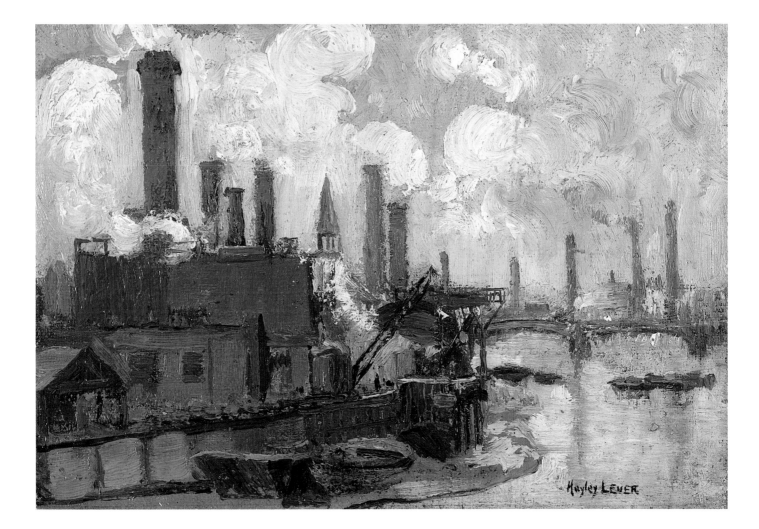

3.

Thames River, London, ca. 1900

Oil on board
6 × 8⅞ inches
Signed lower left: *Hayley Lever*

Like other artists associated with the pictorialization of London—such as James McNeill Whistler, Claude Monet, and Theodore Rousell—Lever often worked along the Thames, recording his immediate perceptions of his environment in small panel paintings such as *Thames River, London*. The artist's direct, shorthand technique imbues this intimate vignette with the improvisatory feel associated with the plein-air tradition. Indeed, the architecture, river traffic, and landscape elements are summarily rendered with dense, creamy strokes, as are the figures on the right, portrayed with a few rapidly applied daubs of pigment. Investigating matters of color and tone as well as natural phenomena, Lever adheres to a low-keyed palette, wherein browns and russets mingle with ivories, buff tones, grays, and traces of pale green and pink—a chromatic scheme that contributes to the poetic mood of the image and that suggests the effects of muted sunlight emanating from the overcast sky.

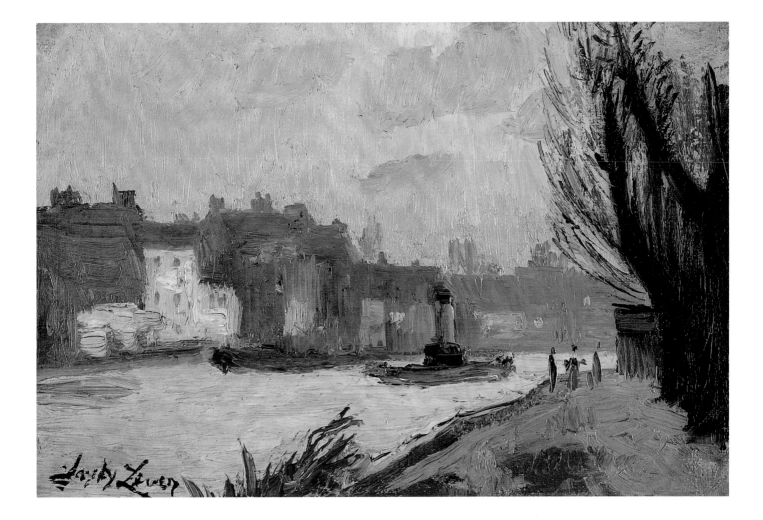

4.

St. Ives, Cornwall, England, ca. 1904

Oil on canvas
10 × 13 inches
Signed lower left: *Hayley Lever*

Located on the north coast of England's Penwith Peninsula, St. Ives was a "paradise for painters," especially for those, like Lever, who were drawn to marine subjects.[1] Artists would typically set up their easels on harborside quays such as the West Pier or on one of the town's four beaches, where they could be found "feverishly recording the movements of boats and water [and] of boating and fishing parties."[2]

Lever explores this very activity in *St. Ives, Cornwall, England,* which shows fishing boats landing with their catch at the edge of the blue-green sea. Painted in a bold, improvisatory technique that captures the immediacy of the moment, the image provides a look at daily life in a Cornish port and stands as an homage to St. Ives's commercial fishing industry.

1. Frank L. Emanuel, "The Charm of the Country Town. III—St. Ives, Cornwall," with illustrations by Captain R. Borlase Smart, *Architectural Review* 48 (July 1920): 15.

2. Emanuel, 12.

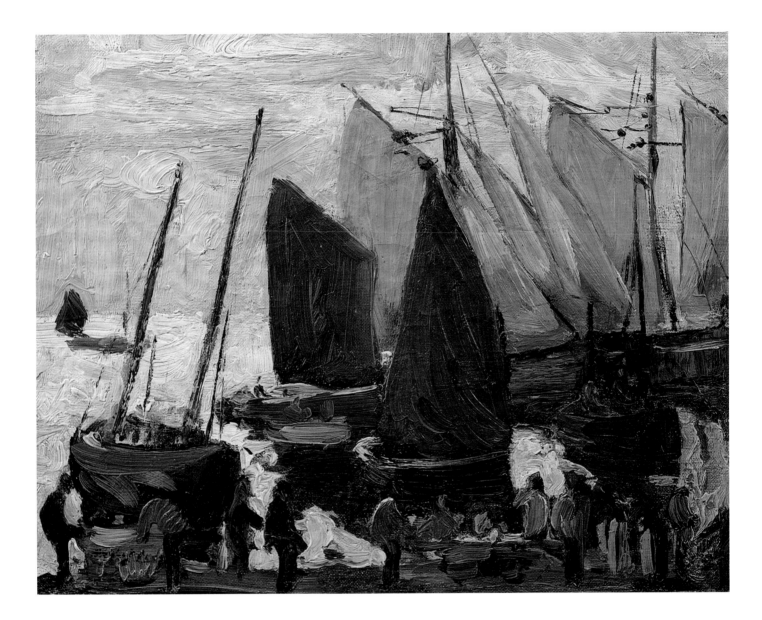

5.

Harbor Scene, St. Ives, 1904

Oil on canvas
40 × 50 inches
Signed lower right: *Hayley Lever*

In keeping with the vogue for evening seascapes that became so fashionable among the painters of St. Ives, Lever presents us with a night scene that shows fishing smacks gliding alongside a path of gleaming moonlight. The buildings of St. Ives's old town appear in the distance, shrouded in a murky atmosphere that softens contours, blurs forms, and infuses the painting with a stirring and very evocative mood. The pinnacled church on the right resembles the old Parish Church, but the shadows of evening make its details illegible, indicating that Lever's aesthetic goal was not architectural or topographical accuracy but the conveying of mood and specific visual effects—which he achieves through relaxed brushwork and a low-keyed tonal palette.[1]

1. This painting was once thought to be a Devon harbor scene. However, according to Janet Axten and John McWilliams of the St. Ives Archive Study Centre, the view depicts St. Ives—identifiable by the markings "SS," that appear on the boat on the far right and on the sails of the boat on the far left. During Lever's day, all vessels had an alphabetical prefix used to denote the port of registration; "SS" was the prefix for St. Ives.

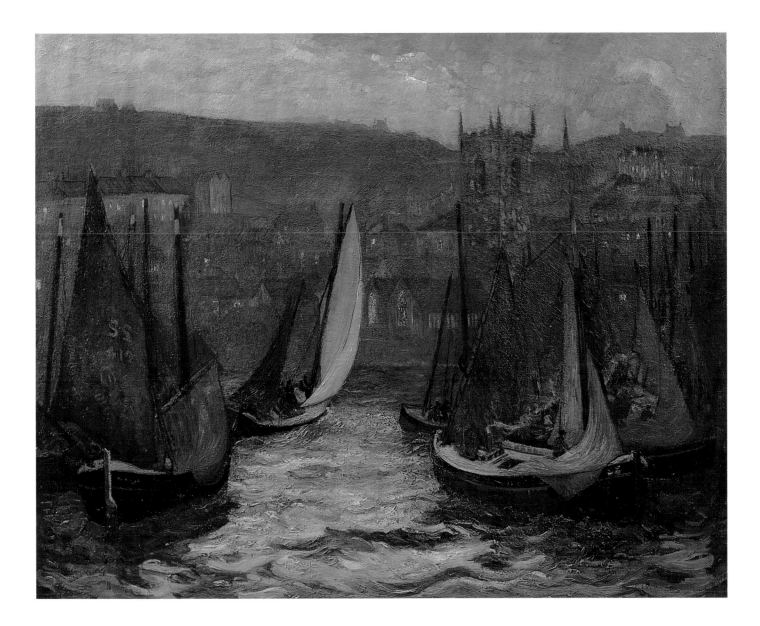

6.

Regatta, ca. 1900s

Charcoal on paper
5½ × 8½ inches
Signed with artist's monogrammed initials lower center: *H L*

In addition to fishing boats and warships, pleasure craft formed an important part of Lever's marine iconography, as exemplified by this informal drawing of sailboats bobbing in the sea, not far from an unidentified European shoreline with houses and churches clustered around a central tower. Rendered in a cursory shorthand with the point of the crayon, the racing boats are identical in form, conceived as simple, rhythmic shapes that seemingly float against the underlying beige ground. By contrast, Lever imparts a more forceful handling to the adjacent landscape, using a broader application of his medium to define the architecture and the rolling, tree-covered topography and impressing us with his ability to render form and mass. Directness and spontaneity are the keynotes of this delightful drawing.

7.

Mevagissey, Cornwall, ca. 1910

Charcoal on paper
10 × 14½ inches
Signed lower right: *Hayley Lever*
Inscribed lower right: *Cornwall / Mevagissey*

During his years in St. Ives, Lever made painting trips through-out the county of Cornwall, visiting such picturesque locales as Mevagissey, an ancient fishing village on the southern coast. Named after Saints Meva and Issey, this historic town—once an important center of boatbuilding and a smuggler's haven—offered the painter appealing motifs in the form of white-washed fishermen's cottages nestled on a sloping hillside and a double harbor replete with fishing trawlers and other types of craft.

Executed from a high cliff, this charcoal drawing features a view of the inner harbor, bounded by narrow streets and clusters of cottages on the left and by a breakwater on the right. Lever depicts the scene with a firm hand, recording his subject by means of broad strokes, nimble outlines, and areas of both vigorous and finely nuanced shading. The "simple treatment and deft arrange-ment of masses" exemplified in Lever's Post-Impressionist work is revealed to perfection in this spirited rendering of a historic Cornish seaport.[1]

1. W. H. [de B.] N[elson], "A Painter of Harbours: Hayley Lever," *International Studio* 52 (May 1914): lxxi.

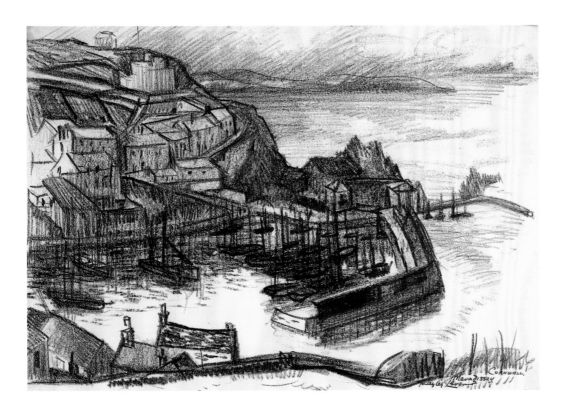

8.

Harbor by Moonlight, St. Ives, ca. 1910

Oil on canvas
30 × 40 inches
Signed lower right: *Hayley Lever*

In the catalogue of Lever's one-man show at the Memorial Art Gallery in Rochester, New York, in 1914, the artist was acknowledged as a "painter of harbor scenes … [whose] special study has been scenes along the southwest coast of England—Cornwall and Devon—and in particular the town and harbor of St. Ives."[1]

The writer's comments are revealing, for it was on the basis of his Cornish subjects that Lever initially established his reputation in the United States. The public found this subject matter new, exotic, and highly enticing, while critics lauded his feeling for light, atmosphere, and the ever-changing movement of water, and praised his ability to translate the spirit of Cornwall into paint.

Lever portrayed St. Ives at all times of day, under morning mists, under the gentle luminosity of afternoon, and "at all tides and under all clouds, with water gray and dull, brilliant green, deep and blue."[2] Inspired by the example of his teacher, the British Impressionist Julius Olsson, who made the "evening effect" fashionable among the artists of St. Ives, he also painted nocturnes, creating romantic seascapes such as *Harbor by Moonlight, St. Ives*.[3] As was typical in Lever's work, a fleet of boats serves as the focal point of the composition, their billowing sails creating unusual patterns that stand out against the broad expanse of iridescent sky.[4] The vessels are moored off the edge of West Pier (erected 1894), whose decorative lamppost can be seen on the far right.[5]

In keeping with the nature of his subject, Lever depicts the vista in a tonal Impressionist manner, using soft brushwork to render the boats and nearby jetty and interpreting the clouds as broad masses hovering in the sky. His predominately blue-green palette imbues the image with an evocative, other-worldly quality, while bright yellows and oranges signify the glowing disc of the moon and trace the ribbon of moonlight as it falls across the calm waters of St. Ives's harbor.

1. *Exhibition of Paintings by Mr. Hayley Lever of Cornwall, England*, exh. cat. (Rochester, N.Y.: Memorial Art Gallery, 1914), unpaginated.

2. "Lever's Art Is a Revelation," *Post* (Rochester, N.Y.), [1914], Records of the National Arts Club, Archives of American Art, Smithsonian Institution, Washington, D.C., reel 4266, frame [illegible].

3. "A Letter from St. Ives, Cornwall," *Studio* 3 (1887): 55.

4. The two boats in the center are pilchard boats (the smaller class of St. Ives sailing lugger), which are going out to sea to fish for herring. The white boat on the left is a St. Ives gig, a smaller undecked rowing and sailing boat, which is also heading out to sea. Herring fishing dominated the commercial fishing industry in St. Ives from about 1890 to 1940. Today, there is no herring fishing in St. Ives.

5. Janet Axten of the St. Ives Archive Study Centre kindly identified the location of the scene and identified the vessels. The lighthouse at the end of Smeaton's Pier appears just above the sail of the vessel on the far left.

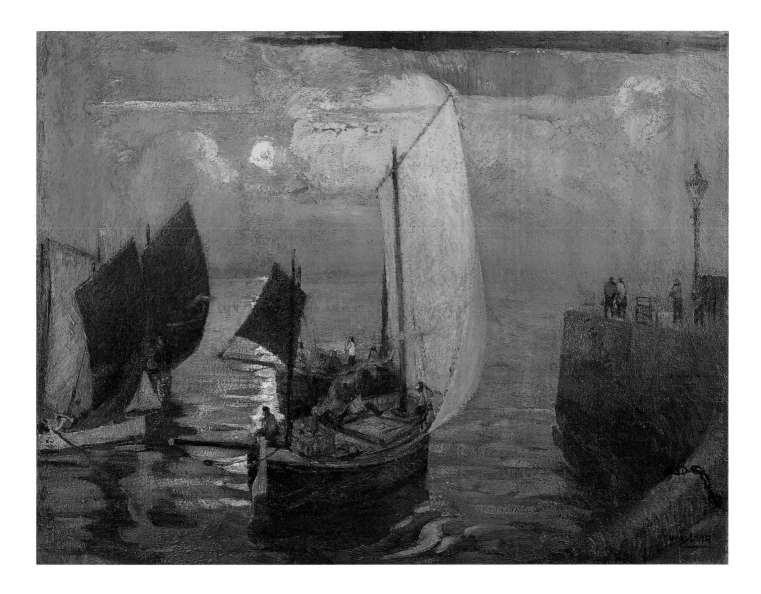

9.

Landing Fish, St. Ives, Cornwall, England, ca. 1910

Oil on canvas
40 × 50 inches
Signed lower right: *Hayley Lever*
Private Collection

Many of Lever's St. Ives canvases depict scenes of daily life, which naturally revolved around the fish trade. One occurrence recorded by his brush involved boats returning in the morning with the evening's catch, which would then be auctioned off "to the fish buyers whose little shanty offices, along with the fishermen's lodges or look-out clubs, crowd the beach."[1]

Lever describes this very activity in *Landing Fish, St. Ives, Cornwall, England,* which shows a fleet of luggers (identifiable by their quadrilateral lug sails), their occupants busily transferring herring to small punts which transport it to the nearby shore, where the fish would be counted into barrels by the fishermen's wives. In viewing the work, one becomes very much aware of the topography of St. Ives, with its sturdy, slate-roofed granite houses jam-packed together on narrow cobblestone streets.

Whereas the majority of St. Ives's painters worked in a modified Impressionist manner, Lever moved beyond that style to incorporate the structural and decorative aspects of Post-Impressionism into his work. His manner of painting sparked the interest of many American critics, among them Edgar Holger Cahill, who characterized Lever's oils as showing "good use of color, excellent draughtsmanship and arrangement of masses, and a fine feeling for the suggestion of life and movement"—traits that are exemplified in *Landing Fish, St. Ives, Cornwall, England.* To be sure, the artist's well-thought-out design and his preference for stylized, repeated forms imbue the scene with a sense of geometric and pictorial order and provide a contrast to the much more fluid rendering of the water. Lever's subtle contour lines, applied to the boats and houses, create recurring patterns that lead our gaze around the composition before coming to rest on the figures assembled on shore. His palette—a veritable rainbow of jewel-like hues—imparts richness and luminosity to the painting, which is both a decorative arrangement as well as a view of what one commentator aptly referred to as "a fisherman's and an artist's town."[3]

1. Frank L. Emanuel, "The Charm of the Country Town. III—St. Ives, Cornwall," *Architectural Review* 48 (July 1920): 13. The small hut on the far right is the One and All Lodge, one of the look-out clubs, or lodges, that Emanuel refers to. I would like to thank Janet Axten of the St. Ives Archive Study Centre for identifying this building and for supplying additional details relative to the site. The herring season in St. Ives usually lasted from October until the end of December.

2. Edgar Holger Cahill, "Hayley Lever, Individualist," *Shadowland* 7 (November 1922): 77.

3. Emanuel, [11].

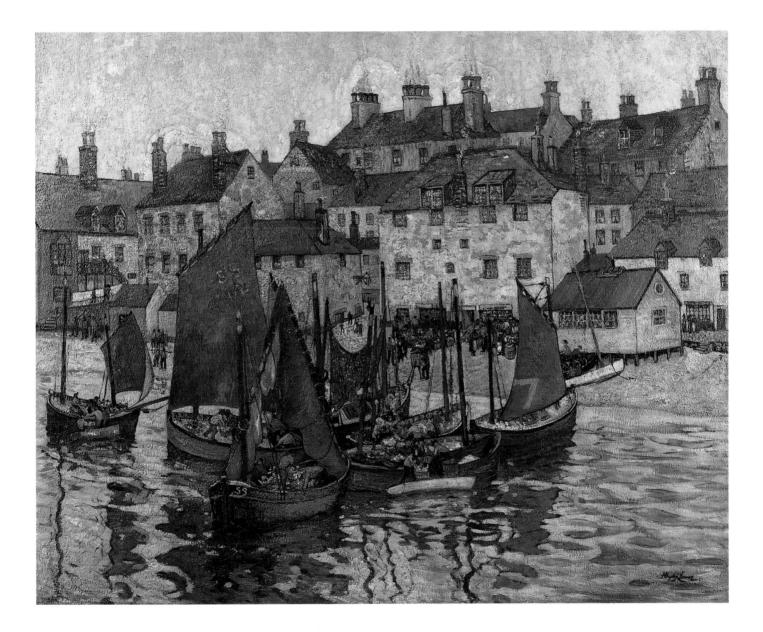

10.

The Port of St. Ives, Cornwall, England, ca. 1910

Oil on canvas
24 × 30 inches
Signed lower left: *Hayley Lever*

A fixture of the St. Ives art colony during the first decade of the twentieth century, Lever played cricket with the Artists' Eleven and fraternized with the many artists from Britain, North America, and Europe who made seasonal trips to this ancient town on the sea. However, he spent most of his time painting, creating eye-catching panoramas such as *The Port of St. Ives, Cornwall, England.*

This view of the harbor was probably taken from Smeaton's Pier, the long jetty depicted in *A Windy Day, St. Ives, Cornwall, England* (Cat. 11), where local fishermen landed with their catch in the morning.[1] As in that work, the tide is out and the vessels (large mackerel boats and smaller pilchard boats) are drawn up on the broad, sandy beach, but in this instance the artist provides us with a view of St. Ives's sturdy hillside houses, built of blocks of gray stone and granite, their rooftops covered with gray-green slate.[2] Despite their disparity in size and form, the dwellings, as noted by one contemporary commentator, are "bound together ... under a general tone of silver-white and silver-grey, here and there tarnished with a golden rust."[3]

On the far right stands the 119-foot-high tower of the old Parish Church, built during the 1420s (consecrated in 1434) and dedicated to Saints Peter and Andrew (the fishermen) and to Saint Ia, an Irish priestess who is said to have arrived on the shores of St. Ives in the fifth century after crossing the Irish Sea on a leaf, and from whom the town derived its name.[4] St. Ives's lifeboat house stands directly to the right of the church, its red door appearing between two crossed masts. These structures are flanked at the front by West Pier, described as an "idlers' paradise, whence may be noticed all the activities of the harbour on one side, and the glistening bay on the other," and indeed, Lever does show a few people strolling along its walkway.[5]

Other notable landmarks in the image include a small black building on the left—a former carpenter's shop that in 1890 became the home of the St. Ives Arts Club and that is now the only half-timbered structure remaining in the town. The dark green spire in the upper portion of the composition is that of the

Catholic church, consecrated in 1908, about the time Lever would have painted this work.

Lever's indebtedness to Post-Impressionism is evident in his concern for conveying mass, volume, and structure rather then the fleeting and the momentary. Certainly, the high horizon line and the rendering of the houses as Cézannesque, block-like forms impart a geometric character to the image and, along with the angular masts, create lively two-dimensional patterning and linear movement. Lever adheres to a more fluent handling in the foreground, while continuing to apply his pigment in a dense impasto to produce a crisp, tactile surface. The silvery, mother-of-pearl tones that make up much of his palette bring to mind the words of the author Virginia Woolf, who described St. Ives as a "narrow-streeted town; the colour of a mussel or a limpet; like a bunch of rough shell fish clustered on a grey wall together."[6]

1. Janet Axten, of the St. Ives Archive Study Centre, identified the various landmarks and boats depicted in the work. Axten notes that although the houses of St. Ives do rise up in terraces, the terrain is not as steep as shown in Lever's painting. The broad patch of green meadowland in the upper right has since been turned into a parking lot.

2. The black (tarred) boats are luggers, used for fishing in distant waters off the coast of Sicily, and in the Irish and North Seas. The smaller craft are pilchard boats used for fishing (pilchard and herring) closer to shore. The vessel with the red funnel is probably the Edgar, SS66, a steamboat built in Grangemouth, Scotland, and sold from St. Ives in 1934.

3. Frank L. Emanuel, "The Charm of the Country Town. II—St. Ives, Cornwall," with illustrations by Captain R. Borlase Smart, *Architectural Review* 48 (July 1920): 13.

4. It was there that Lever married Aida Smith-Gale in 1906.

5. Emanuel, [12].

6. Virginia Woolf, quoted in Robert Andrews, *The Rough Guide to Devon & Cornwall* (London: Rough Guides, 2001), 237.

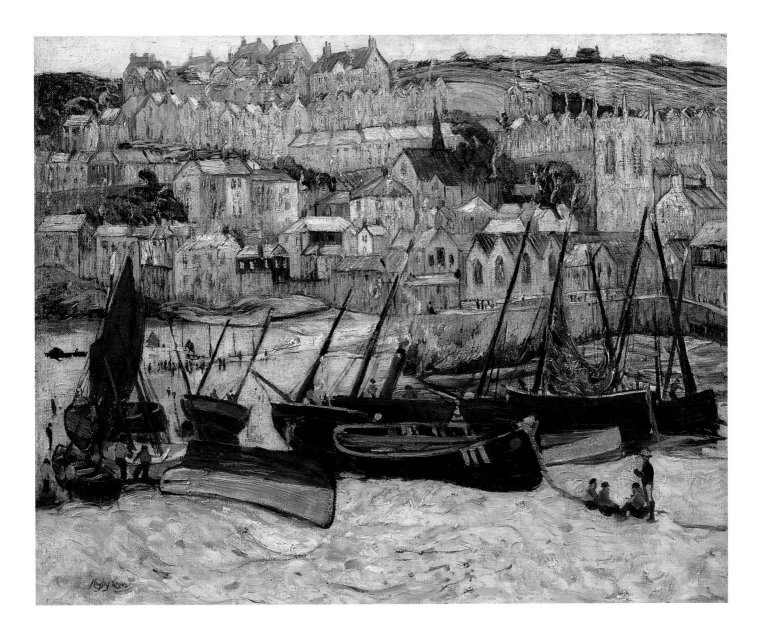

11.

A Windy Day, St. Ives, Cornwall, England, ca. 1910

Oil on canvas

40 × 50 inches

Signed lower right: *Hayley Lever*

Lever arrived in St. Ives, described as "one of the most beautifully placed of [England's] coastal towns," about 1899 and remained there (with the exception of an extended trip to Australia in 1904–05) until 1912.[1] During these years, he painted many views of the local harbor, including this portrayal of a large lugger, or mackerel boat, stranded by low tide on a stretch of sandy shore. On the far right, we are afforded a glimpse of Porthminster Beach, and above that the Tregenna Woods, its lush trees profiled against a blue sky with billowing clouds. A portion of Smeaton's Pier[2] can be seen on the right, along with other vessels large and small—reminding us that St. Ives's inhabitants earned their living as commercial fishermen, herring and mackerel being the staples of the local fishing industry.[3]

By this point in his career, Lever had developed a Post-Impressionist style in which he conjoined his interest in form, structure, and decorative patterning to a concern for light and air. He applies that approach here, interpreting the boats, architecture, and landscape as stylized shapes, emphasizing mass and volume through controlled brushwork and using rhythmic contour lines to impart animation to the work. He adheres to a looser handling in rendering the beachfront, water, and sky, applying his pigment in thick, impastoed strokes. His palette is rich and varied, the deft balancing of light and dark hues contributing to the vigor and strength of the image and helping convey the clear luminosity of a summer's day.

On the basis of works such as this, Lever became known as an artist whose name was inextricably linked to Cornwall and St. Ives. American critics were especially responsive to his Cornish pictures, among them Edgar Holger Cahill, who wrote:

> of the many painters who have painted St. Ives, no one has made the place so peculiarly his own as Hayley Lever. The houses, the harbor, the water, the masts picking up angular patterns in to the sky, the boats riding recklessly at anchor … no one has caught these things as Hayley Lever has caught them, or put down so much of the peculiar life and vitality.[4]

1. Ethel E. Bicknell, *St. Ives, Cornwall, with its surroundings: A Handbook for Visitors and Residents* (London: Homeland Association, Ltd., [1920], [11].

2. Smeaton's Pier was built during 1766–67 by John Smeaton, an important civil engineeer. About 1888 or 1890 the jetty was extended by 280 feet and a new lighthouse placed at its extremity. It is this section, referred to as the Victoria Extension, that is portrayed in Lever's vista. I would like to thank Jane Axten of the St. Ives Archive Study Centre for her kind assistance in identifying the site. Smeaton's Pier is also discussed in Bicknell, 21.

3. The white boat on the left is a rowing and sailing gig. The vessel next to it is a mackerel boat, shown drying its nets in the late summer air. The small boat on the shore in the lower right is a seine boat, used for inshore seine fishing for pilchards, which usually took place from August until October. Information courtesy of John McWilliams of the St. Ives Archive Study Centre.

4. Edgar Holger Cahill, "Hayley Lever, Individualist," *Shadowland* 7 (November 1922): 11, 77.

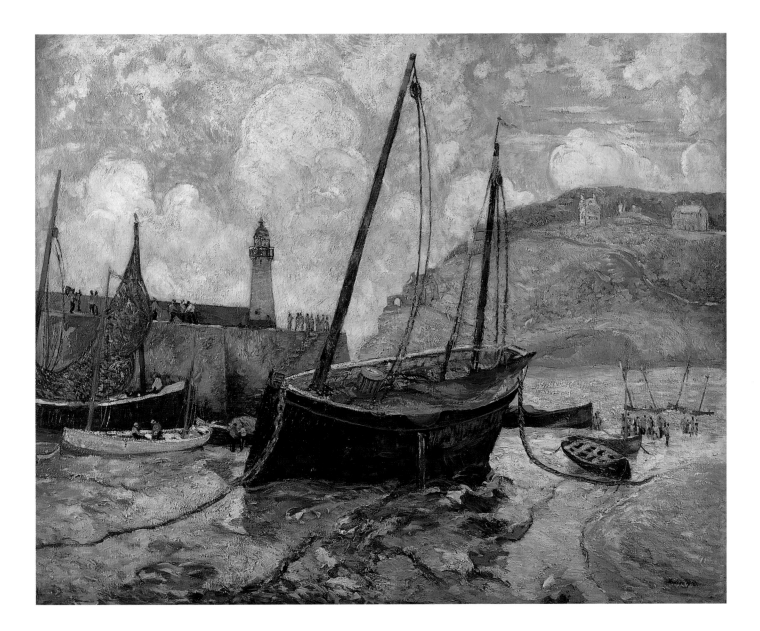

12.

Sunshine in the Hills—The River Exe, 1910

Oil on canvas
40 × 50 inches
Signed and dated lower right: *Hayley Lever / 1910*
Collection of Sandi and Bob Durell

While living in St. Ives, Lever had the opportunity to travel throughout southwest England in search of motifs for his brush. Thus it is not surprising that his oeuvre includes numerous paintings done in the adjacent county of Devon. While sharing Cornwall's nearness to the sea, Devon's topography differed from that of its more rugged neighbor in that it had a more pastoral look, created by the presence of rolling farmland and pretty rural villages. Many of Lever's Devon subjects were done along the River Exe, including this picture of fishing boats, their white sails silhouetted against a backdrop of hills covered with patches of trees and meadows.[1]

While Lever's interest in conveying brilliant sunlight indicates an ongoing concern for rendering natural phenomena, oils such as *Sunshine in the Hills—The River Exe* demonstrates his ability to meld that concern with the precepts of Post-Impressionism. Indeed, his affinity for picturing mass and architectonic structure is evident in the lucid arrangement of the composition into horizontal bands of water, land, and sky and in his emphasis on two-dimensional design, whereby forms appear as if flattened on the picture plane. Working with a loaded brush, he distinguishes the diverse components of the scene by varying his application of pigment. The boats, for example, are decisively rendered with a network of delicate lines articulating masts and riggings. This method contrasts with the gutsy brushwork that evokes the choppy water in the foreground and the short, rapid strokes appearing in the landscape, both techniques generating the animated surface textures Lever so often favored. He uses an altogether different approach in the sky, interpreted in a Neo-Impressionist manner with square patches of color laid side-by-side.

Painted in 1910, *Sunshine in the Hills—The River Exe* is a quintessential Lever, representing the bold Post-Impressionist style he brought to America that caught the eye of many critics. As one art aficionado declared: "Direct and simple treatment, fine color, and extreme vitality characterize his works, and their vigor and sincerity make an irresistible appeal to the modern spirit."[2]

1. The vessels include, in the background, a steam tug towing a ketch-rigged coaster (cargo vessel), upriver to Topsham or Exeter. Identification courtesy of Janet Axten of the St. Ives Archive Study Centre.

2. *Exhibition of Paintings by Hayley Lever*, exh. cat. (Rochester, N.Y.: Rochester Memorial Art Gallery, 1914), unpaginated.

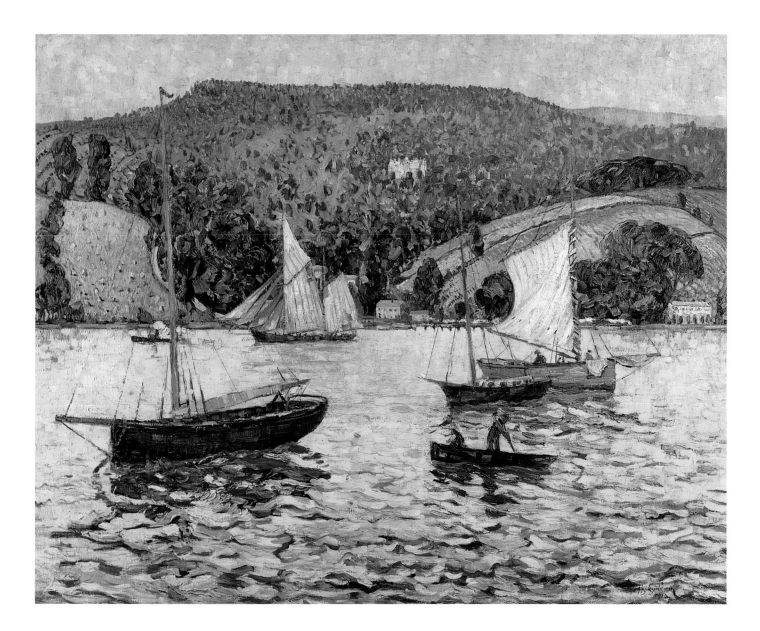

13.

U.S.A. Battleships, River Hudson, New York, 1912

Mixed media on paper
10 × 13¾ inches
Signed lower right: *Hayley Lever*
Inscribed and dated on lower edge:
 New York 1912 / U.S.A. Battleships / River Hudson

In 1912 Lever left his home in the ancient fishing village of St. Ives, England, and came to New York City. The change in scenery would certainly have been dramatic, but Lever responded to the challenge of his new surroundings with his usual enthusiasm, directing his creative energies toward New York's harbors and waterways. In addition to working in Lower Manhattan and along the East and Harlem rivers, he also frequented the banks of the Hudson, capturing its vibrant industrial life and diverse river traffic in oils and works on paper.

Executed from a vantage point in northern Manhattan (an area to which he was probably introduced by his friend and fellow artist Ernest Lawson), *U.S.A. Battleships, River Hudson, New York* features a group of vessels—presumably en route to or from the Brooklyn Navy Yard (officially known as the New York Naval Shipyard)—making their way along the Hudson, which could accommodate large, ocean-going craft as far north as Albany. Our gaze is immediately drawn to the massive dreadnought in the middleground, its smokestacks and tall gun turrets profiled against the Palisades of northeast New Jersey.

Lever employs a variety of media, making use of both graphite and pastel to render the landscape elements and boats. His handling varies throughout the composition, the sketchy treatment of the trees, for example, providing a contrast with the dense, angular strokes used to describe the warship. Lever creates delicate atmospheric effects by rendering the distant landscape with a lighter touch, a technique that offsets the more emphatic handling of the boats, conceived as simple masses. Watercolor also appears in the work, used to suggest the shimmering reflections of sunlight on the water and on portions of the vessels and the far shore. Subtle washes of blue and pink denote the time of day as sunset.

As revealed in *U.S.A. Battleships, River Hudson, New York*, Lever was a versatile artist who easily adapted to his new milieu. To be sure, this vignette stands as one of the artist's earliest impressions of New York and its environs, a locale that would supply him with subject matter for decades to come.

14.

Boston Public Garden, ca. 1915

Graphite on paper
11 × 15 inches
Signed lower left: *Hayley Lever*
Inscribed lower center: *Boston Common*

Recognized for his "excellent draughtsmanship," Lever took his sketchpad on his travels to such New England coastal locales as Gloucester, Massachusetts, where he spent many of his summers from 1915 and into the early 1930s.[1] On one such excursion he stopped in Boston, where he depicted the lagoon and suspension bridge in the Public Garden.

Situated between the Back Bay and Beacon Hill districts in the heart of the city, the twenty-four acre Public Garden was established in 1836 on former marshland as a botanical garden and green space for the public. In 1859 city officials decided to cultivate the area using an English-style landscape scheme that included the planting of tulip bulbs and other annuals, as well as the construction of a lagoon (1861) traversed by a miniature suspension bridge designed by William G. Preston (1869). That the park was an ideal place for peaceful relaxation and outdoor recreation is evident in Lever's panorama, in which an array of rowboats (since replaced by the well-known Swan Boats) make their way along the calm waters of the lagoon, observed by leisure-goers on the shady banks of the nearby shore and on the ornamental bridge. The Public Garden was often confused with Boston Common, the larger forty-eight-acre park located on the other side of Charles Street, as evidenced by the inscription on Lever's drawing.

Boston Public Garden reveals Lever's ability to exploit the expressive potential of line, using it to inject verve and animation into an outdoor composition, while retaining a realistic interpretation of his subject. This is especially apparent in the foreground, where the artist defines the boats, bridges, and trees in an emphatic, robust manner, alternating between dark contours and short, wavy strokes often placed parallel to one another. He describes the landscape elements on the right and in the distance with a more delicate touch, conveying a sense of aerial perspective and creating subtle tonal contrasts. Indeed, Lever's deft manipulation of his medium captures the scenic beauty of the Public Garden, an idyllic haven for Boston's citizenry.

1. Edgar Holger Cahill, "Hayley Lever, Individualist," *Shadowland* 7 (November 1922): 17.

Hayley Lever

Boston Common

15.

Dances of the Boats, ca. 1916

Oil on canvas
40 × 50 inches
Signed lower left: *Hayley Lever*
Collection of Matthew M. Vaccaro and Donna A. Salvatore

In her discussion of progressive trends in American painting, which appeared in the December 1921 issue of *Art in America*, Catherine Beach Ely identified Lever as a non-academic painter, an experimenter who "breaks away from scholasticism in Art and abjures the static; he makes a creed of motion—a boat must tug at its anchor, the waves strain, the flowers twist on their stems."[1]

Ely's remarks call to mind works such as *Dances of the Boats*, which shows a group of sprightly rowboats and sailboats rocking to and fro in a restless New England waterway. The setting sun hangs close to the horizon, illuminating the cloud-streaked sky and casting a ribbon of vivid sunlight across the broad inlet.

Lever's innate feeling for movement is exemplified in the vessels, treated as simplified, two-dimensional forms shown tipped up or down and at various angles as they respond to the ebb and flow of the water. Activity and motion are also transmitted through the fluent, swirling brushwork that describes the vigorous rhythms of the waves—portrayed with a strident palette that parallels the emotive colorism of Vincent van Gogh and points to a familiarity with the chromatic concerns of Fauvism too. Indeed, *Dances of the Boats* reveals, as perceived by one commentator of the period, that "As a colorist, Lever is supreme. His boats and water are alive. Everything he does has strength and vitality and without doubt he is one of the greatest painters of the day."[2]

1. Catherine Beach Ely, "The Modern Tendency in Lawson, Lever, and Glackens," *Art in America* 10 (December 1921): 32.

2. "St. Ives in America," *St. Ives Times*, 19 September 1924.

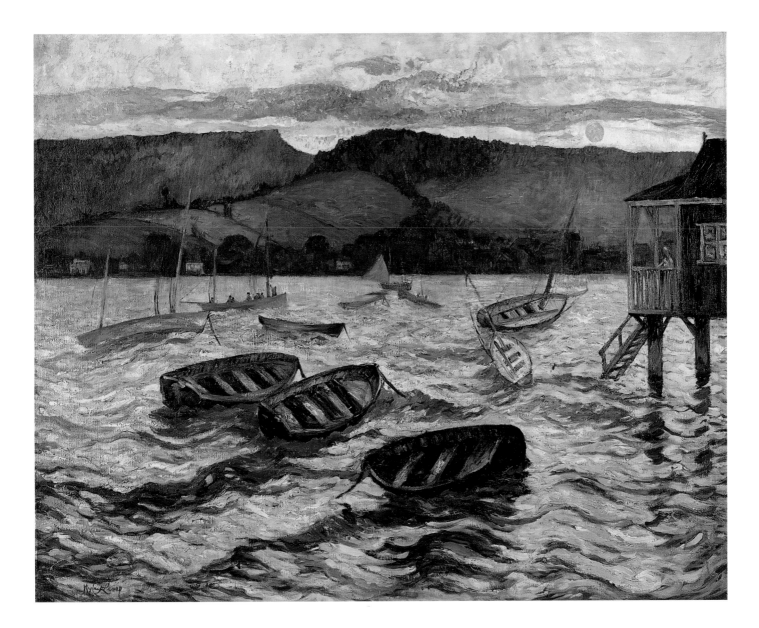

16.

Flags, 1917[1]

Oil on canvas
25 × 30 inches
Signed and inscribed lower right: *Hayley Lever /*
British-French Commission
Collection of Thomas L. Phillips

In the wake of his move to New York, Lever portrayed all facets of the contemporary metropolis, from local bridges and the gritty waterfront to Central Park and the Sixty-sixth Street El. He also applied his able brush to the streets of Manhattan, including Fifth Avenue, the famous thoroughfare that attracted the attention of many turn-of-the-century American painters, among them such Impressionists as Childe Hassam and Colin Campbell Cooper and Tonalists such as Birge Harrison and Paul Cornoyer.

One of Lever's most ambitious street scenes, *Flags* is not just a modern urban landscape but a war-related image—inspired by the visits of the British and French war commissioners in May of 1917, when the city organized displays of flags and banners commemorating the newly formed alliance between America, Britain, and France.[2] Although such decorations appeared on other streets and avenues throughout the city, they were most conspicuous on Fifth Avenue, which became known as the "Avenue of the Allies."[3]

Painted from an elevated vantage point at Fortieth Street, the scene depicts a stretch of Fifth Avenue looking north toward Saint Patrick's Cathedral (designed by James Renwick and built between 1859 and 1879) at Fiftieth Street, its twin spires profiled against a blue sky. Other significant landmarks appearing in the image include portions of the façade, terrace, and steps of New York Public Library (designed by Carrère and Hastings and constructed between 1897 and 1911) in the lower left, along with the pair of lions sculpted by Edward Potter.[4] Farther up, on the right, we encounter the Temple Emanu-El (erected 1868 after a design by Leopold Eidlitz and demolished between 1927 and 1929) nestled amid tall office buildings at Fifth Avenue and Forty-third Street. The sunny vista is replete with movement and a sense of excitement, produced not only by the diverse architecture but also by the throngs of marchers, spectators, and vehicles and by the conglomeration of flags and standards, dominated by the French Tricolor and the Stars and Stripes fluttering in the summer breeze.

Lever's indebtedness to Post-Impressionism can be seen in his tight definition of the buildings and in the emphasis on dynamic patterning, created by the repeated shapes of the flags and banners. The artist's palette, wherein soft yellows and grays merge and mingle with Fauve-like touches of red, white, and blue, creates vibrant chromatic contrasts throughout the composition and enhances the celebratory spirit of the scene. This stunning canvas attests to Lever's ability to interpret the tempo and spirit of the modern American city; it is undoubtedly one of his most outstanding contributions to the pictorial history of New York.

1. This may be the work Lever exhibited at the Buffalo Fine Arts Academy, Albright Art Gallery, in December 1920, at the Toledo Museum of Art in January 1921, and at Syracuse Museum of Fine Arts in April 1921 under the title *Fifth Avenue, French and English Commission, 1917*. See *Catalogue of Four Special Exhibitions: Paintings by Frederick Carl Frieseke, N.A., Paintings by Maurice Fromkes, Paintings and Etchings by Hayley Lever, Paintings by Jonas Lie*, exh. cat. (Buffalo: Buffalo Fine Arts Academy, Albright Art Gallery, 1920), no. 42, *Catalogue: Paintings and Etchings by Hayley Lever, Paintings and Drawings by Henry I. Stickroth, Interior Decoration Exhibition*, exh. cat. (Toledo, Ohio: Toledo Museum of Art, 1921), no. 207, and *Catalogue of an Exhibition of Paintings and Etchings by Hayley Lever*, exh. cat. (Syracuse, N.Y.: Syracuse Museum of Fine Arts, 1921), no. 13.

2. The British and French Commissioners visited the city on the 9th and 11th of May respectively.

3. The subject of America's participation in World War I was pursued with the greatest enthusiasm by Hassam, who produced a series of about thirty flag paintings. For this aspect of Hassam's oeuvre, and for information on the wartime decorations along Fifth Avenue, see Ilene Fort, *The Flag Paintings of Childe Hassam*, exh. cat. (Los Angeles: Los Angeles County Museum of Art, 1988).

4. An admirer of the French Impressionists Claude Monet and Camille Pissarro, Lever may have been influenced—in terms of composition design—by their street scenes of Paris. He might also have seen Edmund W. Greacen's *Fifth Avenue (Library and Lion, New York, Fifth at Forty-second Street)* (1915; private collection), which depicts a view closely related to that in *Flags*.

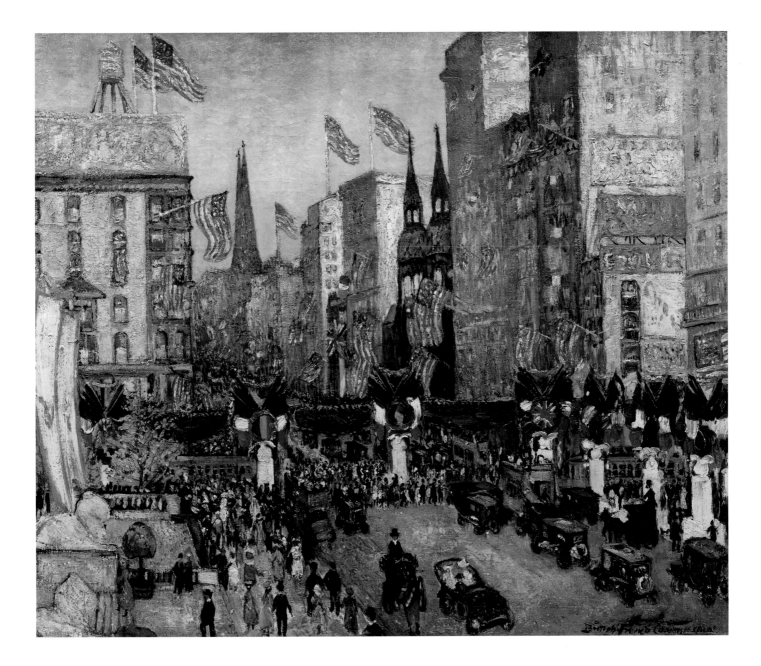

17.

Forty-second Street between Seventh and Eighth Avenues, New York City, 1920

Oil on canvas laid on panel
6¼ × 9 inches
Signed and dated lower left: *Hayley Lever / 1920*

Lever's New York subjects include large-scale works done in the studio as well as smaller, more informal impressions painted in the open air, including this view of a stretch of Forty-second Street in New York's bustling theater district. Taken from an elevated vantage point, the vista includes pedestrian and vehicular traffic moving along the thoroughfare, conceived as a broad diagonal lined with buildings on each side. Their façades are illuminated by a conglomeration of blazing neon signs and electric billboards—a reminder that the lights were one of New York's chief splendors: as noted by one contemporary writer, "Everywhere they flash, they scintillate, staggering and overpowering you . . . and New Yorkers thrill in the atmosphere."[1]

Lever interprets his subject with quick, fluid brushwork, avoiding detail and specificity in favor of a more expressive and generalized conception. His fluid technique imbues the image with a vital sense of movement and spontaneity, while his thick application of pigment creates a richly textured surface. The artist's palette, in which bright reds, yellows, oranges, and daubs of white are offset by dark browns and black, evokes the glamour and glitter of nocturnal New York. Indeed, as revealed in this intimate vignette, Lever was an enthusiastic observer of the modern metropolis, his rapid touch and perceptive colorism capturing the unique look and buoyant spirit of his surroundings.

1. Louis Baury, "The Message of Manhattan," *Bookman*, No. 33 (August 1911): 598, 600.

18.

Fishing Schooners, Gloucester, ca. 1920

Oil on canvas

20 × 24 inches

Signed lower right: *Hayley Lever*

Lever spent part of his early career in St. Ives, an ancient harbor town and artists' colony on England's Cornish seacoast, where he painted depictions of the local harbor, winning acclaim for his vigorous Impressionist style and for his ability to evoke the unique spirit of Cornwall. After settling in New York, he sought an equivalent in America. He found it in Gloucester, on Massachusetts's Cape Ann peninsula, which, like St. Ives, boasted narrow, winding streets, picturesque architecture, a rock-bound coastline, and, most important, a busy port with a wide array of craft.

Lever made his first trip to Gloucester in the summer of 1915, and he returned there frequently throughout the late 1910s and into the early 1930s. During these years, he devoted much of his time to portraying the town's waterfront, evidenced by such stunning canvases as *Fishing Schooners, Gloucester.*

As observed by the collector Duncan Phillips, Lever had a remarkable "zest for design," an aspect of his approach that is evident here.[1] Indeed, the artist presents us with a view of four massive vessels—of identical shapes and size—moored alongside one another, their distinctive forms dominating the composition, which includes some smaller craft and a few dockside buildings on the right. The tall masts and intricate rigging of the schooners soar into the radiant sky, creating rhythmic, angular patterns, their vertical thrust deftly offset by the repeated horizontals of the spars.

The strength and vitality of Lever's art is readily apparent in *Fishing Schooners, Gloucester.* He interprets the massive boats as simplified shapes, alternating between broad strokes and his characteristic dark contours that imbue the image with a lively calligraphic quality and enhance the sense of mass and volume. Lever employs a more fluid, painterly handling to evoke the ripples and vibrations of light on the water, applying his pigment in a thick divisionist manner that produces rich surface textures and that reminds us of his expertise in evoking the movement of the sea. As was typical of his Gloucester subjects, he adheres to a varied palette, balancing luminous greens, yellows, pinks, and

ivories with bold shades of red, orange, and blue, all of which are augmented by touches of white and black.

A work of power and authority, *Fishing Schooners, Gloucester* attests to Lever's keen sense of design, the strength and decisiveness of his touch, and his perceptive colorism. It also reminds us of his love of painting boats—motifs he readily found in America's oldest seaport.

1. Duncan Phillips, *A Collection in the Making* (Washington, D.C.: Phillips Memorial Gallery, [1926]), 58.

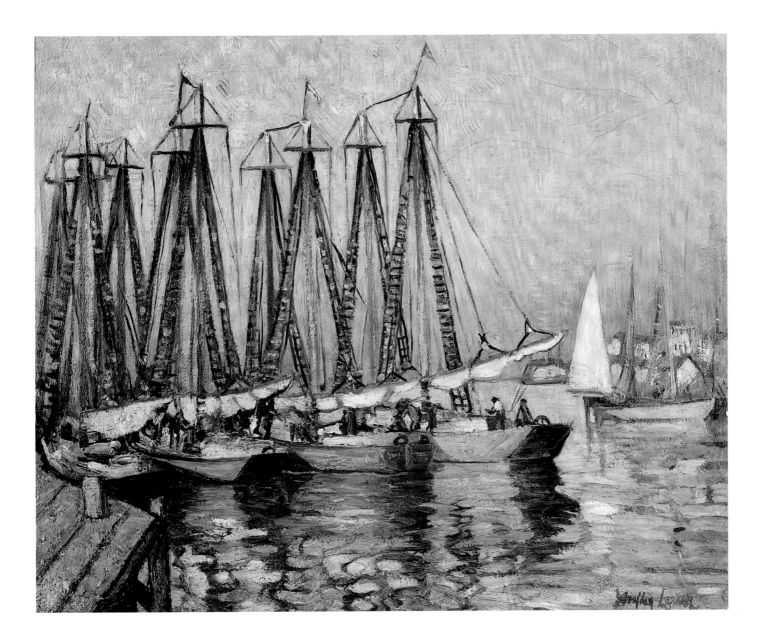

19.

Fishing Schooner, Gloucester, Massachusetts, ca. 1920

Oil on canvas mounted on board
6¼ × 9⅛ inches
Signed lower right: *Hayley Lever*

Observing Lever's partiality for picturing boats, the art patron Duncan Phillips called him a "clever Impressionist and a vigorous painter who employs a technique admirably adapted to his favorite subject. He draws well and places dark accents with a fine sense of pattern. His color is rich and vital."[1]

This statement brings to mind works such as *Fishing Schooner, Gloucester, Massachusetts*, among the outdoor panel paintings Lever produced during his summer excursions to America's most venerable seaport. Making a solitary vessel the focal point of the design—the upper portions of its masts and rigging eliminated by the abrupt cropping of the image—he describes the scene in a rough, virile manner, exploiting the physicality of his medium by employing thick layers of pigment to create a sensuous and powerfully tactile surface. His gestural brushstrokes—in the form of zigzags, daubs, dashes, and sketchy lines—animate the canvas and work with the cool colors to suggest the intricate play of sunlight on the setting. At the same time, Lever's simplified, abstract treatment of form connects him with the modern spirit of the early twentieth century and affirms the breadth and scope of his artistic vision.

1. Duncan Phillips, *A Collection in the Making* (Washington, D.C.: Phillips Memorial Gallery, [1926]), 57. Phillips owned three works by Lever: *Limp Sails, St. Ives; Herring Boats, St. Ives;* and *Inner Harbor, Rockport.*

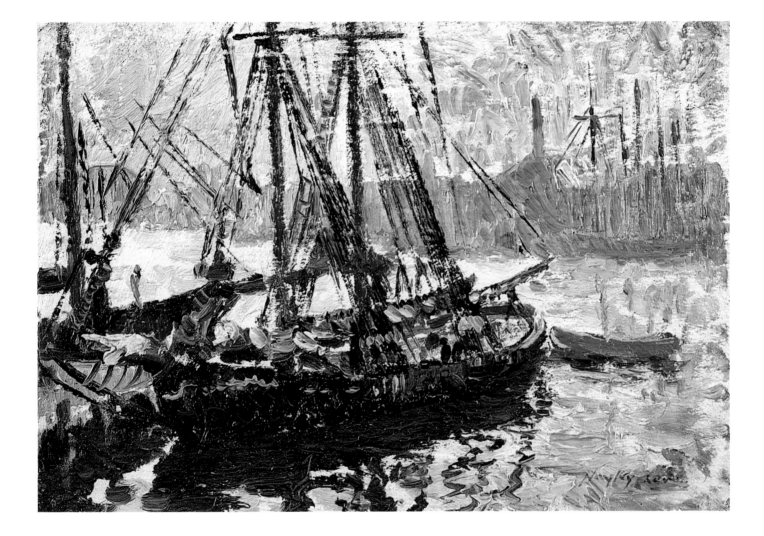

20.

Nantucket, Massachusetts, ca. 1920

Watercolor on paper
11 × 14½ inches
Signed lower center: *Hayley Lever*

Lever was an avid watercolorist, taking great delight in the ease and spontaneity of that medium, as well as in its transparent, light-reflecting quality and its easy portability. In his view, watercolor was "inspirational, immediate, [and] impressionistic."[1]

Lever exhibited his watercolors at the annual exhibitions of the American Watercolor Society in New York and elsewhere throughout the United States. Reviewers responded positively to his work in this medium, praising his direct, atmospheric technique and his modernist vision, based on the simplified forms and subjective colorism of Post-Impressionism. In fact, in a discussion of leading American practitioners of watercolor, the writer Henry Tyrell hailed Lever as "distinctly among those who must be reckoned with as progressives in the lighter medium."[2]

Lever created many of his watercolors on summer painting trips to coastal Massachusetts, including the offshore island of Nantucket. Drawn to its lively waterfront, where one could find pleasure craft, fishermen's houses, and weather-beaten wharves, he made a number of visits there from the mid-1910s into the 1930s, feeling that "Nantucket is among the most beautiful and distinctive places…in which to paint."[3]

In *Nantucket, Massachusetts,* Lever's expert manipulation of form and color captures the joyous mood of a summer's day at the shore. Alternating between diaphanous washes and a heavier, opaque application, he describes the scene with a painterly technique, eschewing detail in favor of a more expressive interpretation of his subject. As was typical of his panoramas of boats and the sea, the view is filled with movement and rhythmic patterning, created by the short, mosaic-like daubs of paint used to evoke the rippling surface of the water and the dark, linear accents that suggest the reflections of boats and portions of the architecture.

1. Quoted in Helen Wright, "A Visit to Hayley Lever's Studio," *International Studio* 70 (May 1920): lxx.

2. Henry Tyrell, "American Aquarellists—Homer to Marin," *International Studio* 74 (September 1921): xxxvi.

3. "Noted Maritime Painter Here," unidentified newspaper clipping, ca. 1933, Richard Hayley Lever Publicity Book, Clayton-Liberatore Gallery, Bridgehampton, New York.

21.

Woodstock, New York, ca. 1922

Watercolor on paper

17 × 22 inches

Signed with the artist's monogrammed initials lower right: *HL*

Signed and inscribed lower left: *Hayley Lever / Woodstock, N.Y.*

Inscribed upper left, upside down: *Fabr. Royal C. P.*

Under the auspices of the Arts Students League, Lever spent the summer of 1922 teaching painting classes in Woodstock, a small village and artists' colony in the eastern Catskill Mountains of upstate New York. This fact was duly observed by the critic Edgar Holger Cahill in the November issue of *Shadowland*, with the writer noting: "Already he [Lever] has made stacks of water-color studies of the Catskills, and we may expect that delightful bit of the American landscape to be added very soon to Lever's country."[1] And so it was, for Lever's sojourn in Woodstock resulted in a number of sparkling landscapes, among them this panoramic view of the town nestled at the base of Overlook Mountain.[2]

By the early 1920s Lever had acquired a notable reputation as a watercolorist—an "eager innovator … [whose] aquarelle no less than his oil painting gains in stirring vitality with each successive season."[3] The critic Henry Tyrell linked him with a new genera-tion of American watercolorists, such as John Marin and Charles Demuth, who were of an "ultra-modern bent," taking their aes-thetic cue from the example of Post-Impressionist painters such as Paul Cézanne, who emphasized simplified forms and used color to create volume and mass.[4]

Lever takes just such an approach in *Woodstock, New York*, evoking the essence of his subject by eliminating extraneous detail throughout the composition. His skillful juxtaposition of transparent washes and lively staccato brushstrokes not only produces a coherent and recognizable design, it also under-scores his steadfast command of watercolor, a light and sponta-neous medium that served him well throughout his career.

1. Edgar Holger Cahill, "Hayley Lever, Individualist," *Shadowland* 7 (November 1922): 77.

2. The church spire belongs to Woodstock's Dutch Reformed Church. Information courtesy Linda Freaney, Woodstock Artists Association, Inc.

3. Henry Tyrell, "American Aquarellists—Homer to Marin," *International Studio* 74 (September 1921): xxxvi.

4. Tyrell, xxxi.

22.

Allegheny River, Pittsburgh, ca. 1923[1]

Oil on canvas
40 × 50 inches
Signed lower right: *Hayley Lever*
Courtesy, CIGNA Museum and Art Collection, Philadelphia

Like a number of his contemporaries—one thinks especially of Aaron Gorson and Otto Kuhler—Lever explored the artistic possibilities of the city of Pittsburgh, renowned for its production of steel, iron, and coal. Indeed, during the early twentieth century, boats and barges crowded the Allegheny and Monongahela rivers, where massive steel and iron mills operated twenty-four hours a day, spewing dense, billowing smoke from their chimneys. The effect was particularly vivid at night, when the heated glow of blast furnaces illuminated the evening sky, creating a spectacular visual phenomenon such as that in *Allegheny River, Pittsburgh.*

Lever would have had the opportunity to depict industrial Pittsburgh when visiting the city in conjunction with the Carnegie International exhibitions.[2] Working from fluent watercolor studies, which probably included *Pittsburgh, Pennsylvania*[3] (Fig. 13), he created large-scale oils such as the present work, which features a view of the Allegheny River looking upstream.[4]

This canvas underscores Pittsburgh's reputation as the "City of Bridges," for Lever depicts three of them—the Sixteenth Street Bridge at the top, followed by the Fort Wayne Bridge, and, at the bottom, the Ninth Street Bridge.[5] On the far right, buildings and smokestacks of iron foundries and glassworks crowd the waterfront—the Wayne Iron and Steel Works, the Fort Pitt Foundry of the Mackintosh Hemphill Company, the Sable Iron Works, and the American Steel and Wire Company were all located in this area—their shapes enveloped in a blanket of smoke and haze that softens and blurs their hard-edged contours.[6] Lever clearly had no desire to document the massive architecture and the manufacturing process, nor did he wish to make a social comment; rather, he was simply responding to the aesthetic potential offered by the smoke-filled atmosphere of his surroundings.

Lever depicts his intricate and exceedingly dynamic composition with varied brushwork, using short daubs and dashes to render the surface of the river, thick, wavy strokes to interpret the plumes of smoke, and a highly controlled touch to visualize the bridges. The distant sky is portrayed with square, mosaic-like daubs of pigment that add to the visual complexity of the painting, as does the artist's fauvist-inspired palette, a co-mingling of vibrant greens, fiery oranges, deep browns, and ample black (a hue Lever was never afraid of using), which result in dramatic contrasts of light and dark.

Lever painted bridges and viaducts in Cornwall, London, and New York. However, his canvases depicting the bridges of Pittsburgh are the most innovative and exciting of his industrial scenes, as revealed in *Allegheny River, Pittsburgh.* Taking a decidedly personal approach to Pittsburgh, the city of "smoke and cinders," Lever maneuvers color and form in such a way as to transform a gritty urban subject into a very dazzling conception, capturing what the writer William Glazier called "a spectacle which has not a parallel on this continent."[7]

1. This may be the work Lever exhibited at the Corcoran Biennial in 1923 under the title *The Allegheny River—Pittsburgh.* See *The Biennial Record of the Corcoran Gallery of Art, 1907–1967,* edited by Peter Hastings Falk (Madison, Conn.: Sound View Press, 1991), 179.

2. Lever showed at the Carnegie International in 1910–14, 1920–26, 1929, 1931, 1933, and 1946. His submission in 1923 was a view of industrial Pittsburgh entitled *Allegheny River at Pittsburgh—Morning.*

3. An inscription on the lower left edge, probably by an unknown hand, incorrectly dates the watercolor to 1930.

4. A related work, which omits the boat, is entitled *Allegheny River* (ca. 1923) and can be found in the collection of the Westmoreland Museum of Art in Greensburg, Pennsylvania.

5. Identified as such by Walter C. Kidney, architectural historian for the Pittsburgh History & Landmarks Commission and the author of *Pittsburgh's Bridges: Architecture and Engineering* (Pittsburgh: Pittsburgh History & Landmarks Foundations, 1999). Correspondence with Spanierman Gallery, 14 October 2002.

6. Information courtesy of the Historical Society of Western Pennsylvania, Pittsburgh.

7. William Glazier, *Peculiarities of American Cities* (Philadelphia, 1883), 332.

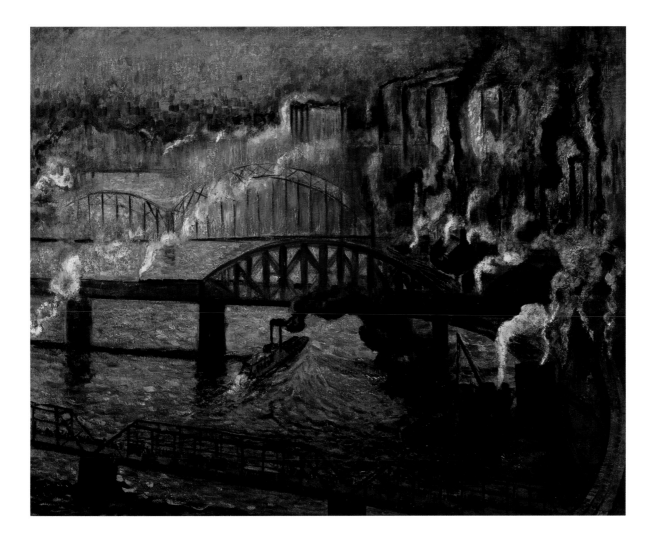

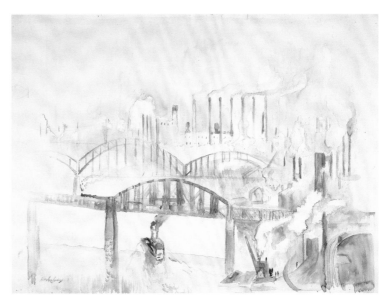

Fig. 13.
Hayley Lever, *Pittsburgh, Pennsylvania*, 1930, watercolor on paper, 15⅛ × 19³⁄₁₆ in., Spanierman Gallery, LLC, New York.

23.

Marblehead, Massachusetts, 1924

Graphite on paper

7½ × 11 inches

Signed with the artist's monogrammed initials, dated, and
 inscribed lower right: *Marblehead Mass / HL / Sept 12 / 1924*

Following his immigration to the United States in 1912, Lever typically spent his summers along the Massachusetts shore, in port towns such as Gloucester and Rockport and on the island of Nantucket. His oeuvre also includes depictions of scenery in Marblehead, a delightful seaside town about seventeen miles northeast of Boston. A former fishing village (founded in 1629), Marblehead offered a wealth of motifs for painters, including pre-Revolutionary architecture and a rockbound coastline. A popular resort since the nineteenth century, Marblehead was also America's yachting capital, boasting sailing clubs and a busy harbor replete with pleasure craft and fishing boats.

Lever was active in Marblehead during the summer of 1924, a visit that was duly noted by a local art lover, who proclaimed: "This year for the first time, we have that great marine artist, Hayley Lever, in our midst," and who predicted that he would "immortalise Marblehead harbor just as he has done St. Ives."[1]

And so he did—in oils and watercolors, as well as in intimate drawings such as *Marblehead, Massachusetts*, which features an expansive panorama of the town's shoreline. The view looks westward into the harbor, the causeway out to Marblehead Neck appearing in the upper left, while in the lower quadrant various sailboats play the calm waters of the bay. The bell tower of Marblehead's old town hall, Abbot Hall (erected 1876–77), can be seen in the upper right.

In drawings such as *Marblehead, Massachusetts,* Lever sought to record his immediate response to his surroundings. Accordingly, he works quickly, describing the scene with rapid strokes of pencil that lend movement and animation to the image. As was typical of Lever's approach, there is a strong linear component to the scene, created by the emphatic contours used to define the architecture, boats, and portions of the landscape. He combines this with areas of broad shading to indicate form and mass and uses the underlying beige ground to give the image a palpable sense of light.

As the drawing demonstrates, Lever was an expert draftsman and a master of the rapid, plein-air sketch. As well as providing us with an engaging image, he skillfully conveys the look and spirit of Marblehead, which he described as a "beautiful and an ideal place to work in."[2]

1. Quoted in "St. Ives in America," *St. Ives Times,* 19 September 1924.

2. Quoted in "St. Ives in America."

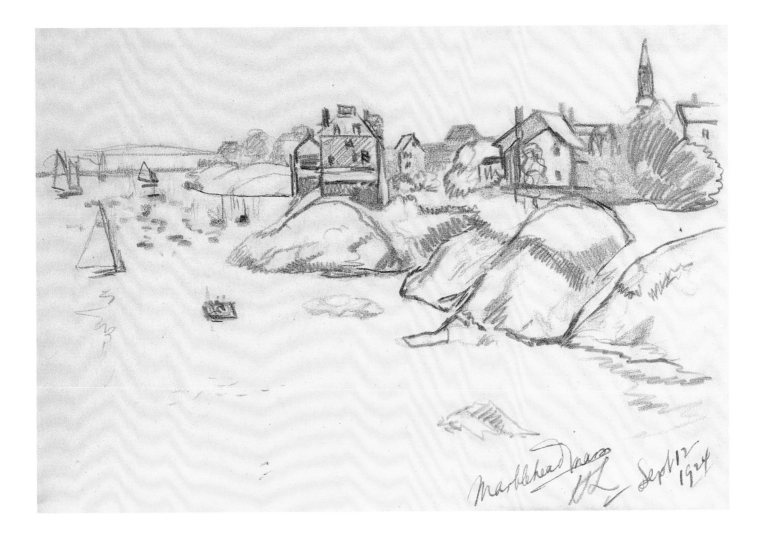

Marblehead Mass. Sept 17 1924

24.

Gloucester, Massachusetts, ca. 1920s

Oil on canvas
40 × 50 inches
Signed and inscribed lower right: *Hayley Lever / Gloucester / Ma*
Private Collection, New York

In the summer of 1915 Lever joined the many American painters who flocked to Gloucester, the scenic fishing port and artists' colony on the North Shore of Massachusetts. Delighted with its pictorial potential and its proximity to the sea, he returned the following year, participating in the inaugural exhibition of the Gallery-on-the-Moors, along with leading members of the local colony, among them Frank Duveneck, Cecilia Beaux, John Sloan, Henry Snell, and Randall Davey. Although other New England coastal locales would also spark Lever's interest, it was to Gloucester that he returned again and again throughout the mid-to-late 1910s and into the early 1930s, applying his able brush to depictions of the town and its busy harbor.

As observed by Helen Wright, the color in Lever's Gloucester scenes could be "brilliant, subdued, or ethereal as the day, night or hour reveals."[1] In this attractive vista, painted on a misty autumn day from the hills at East Gloucester, the artist employs a medley of iridescent pastel hues that are very much in keeping with the hazy climatic conditions he was responding to. The concise, formal stylization and tight patterning of the cottages and trees in the foreground—a standard feature of Lever's mature work—give way to a much softer treatment in the distance, where the clusters of houses, churches, and public buildings seemingly merge and meld together, as if enveloped in a soft, amorphous veil. The artist's opaque brushwork (not unlike that favored by his friend and fellow artist Ernest Lawson) produces a physically palpable surface that, along with his luminous coloration, enhances the unity and harmony of this lyrical and very meditative composition.

1. Helen Wright, "A Visit to Hayley Lever's Studio," *International Studio* 70 (May 1920): lxx.

25.

Gloucester Rooftops and Harbor, ca. 1920s

Oil on canvas
20½ × 24½ inches
Signed lower left: *Hayley Lever*
Private Collection, Atlanta, Georgia

Lever's depictions of Gloucester comprise many views of the town's waterfront, among them *Gloucester Rooftops and Harbor,* painted from a vantage point along East Main Street.[1] Portrayed on an overcast day, the scene includes a number of weathered buildings, their sloping rooftops silhouetted against the sea. The two-storied edifice that appears in the upper right hand corner of the composition is thought to be the renowned Tarr and Wonson Paint Factory (later known as Gloucester Paints).[2] Built in 1863 at the western tip of Rocky Neck, the factory (which manufactured copper paint for boat-bottoms) was a familiar signpost for vessels entering Gloucester Harbor.[2] Lever's tableau also includes a tugboat moving close to shore, where figures can be seen working on the wharves. Farther out, fishing boats rock to and fro in the choppy water, their forms almost completely obscured by a layer of fog and mist. Here, Lever's soft, thick brushwork and pale hues produce evanescent effects that contrast with the direct and more colorful rendering of the foreground.

As this painting demonstrates, Lever was a skilled purveyor of light and air whose vision of Gloucester was wide-ranging, encompassing not only its picturesque schooners and cottages, but its industrialized areas as well.

1. Identification courtesy the Gloucester Historical Society.

2. For the Tar and Wonson Paint Factory, see Joseph E. Garland, *The Gloucester Guide* (Gloucester, Mass.: Gloucester 350th Anniversary Celebration, Inc., 1973), 81–82.

26.

Morning at Rockport, ca. 1920s

Oil on canvas
25 × 30 inches
Signed lower right: *Hayley Lever*

After moving to America, Lever turned his attention to the harbors of New England, painting in scenic coastal towns along the Massachusetts shore, such as Gloucester, Annisquam, and Marblehead. It was probably during one of his summer sojourns in Gloucester, on the Cape Ann peninsula, that Lever visited Rockport, a smaller fishing port and artists' colony a few miles to the north. Named after the local granite quarries, Rockport boasted an old-fashioned harbor replete with all manner of fishing boats as well as wharf-side shanties, fishermen's cottages, and weather-beaten warehouses—motifs that figure prominently in *Morning at Rockport,* which provides a glimpse of local workers alongside the single-masted schooner that serves as the focal point of the composition.

During his years in St. Ives, Lever began incorporating the structural and decorative aspects of Post-Impressionism into his work, while retaining his interest in light, atmosphere, and mood. He brought this progressive outlook with him to America, attracting laudatory reviews for his artistic individualism, which set him apart from the native Impressionist camp. In *Morning at Rockport,* Lever exerts his aesthetic independence, interpreting the water and landscape elements with loose, vigorous brush-work, applied in a thick impasto, and defining the architecture as solid, block-like forms. In classic Leveresque fashion, a network of dark, angular lines—created by rigging and ropes crisscrossing the image—adds rhythm, animation, and patterning to the work and offsets the more static horizontals and verticals of the masts and booms. In viewing the picture, one gets a real sense of place, as well as the presence of sturdy boats, rippling water, and fresh sea air.

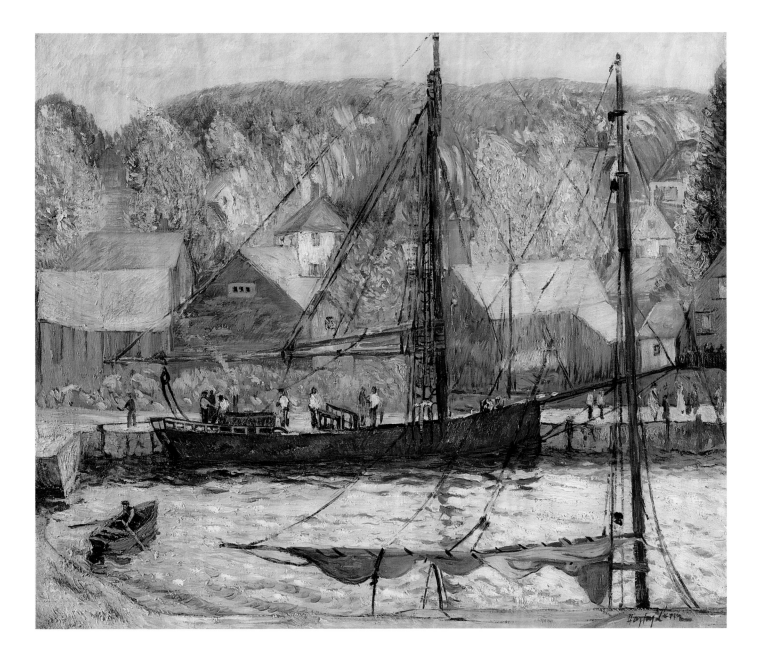

27.

**New York Skyline from the
Lackawanna Ferry Depot,** 1928

Oil on canvas
20 × 24 inches
Collection of Dr. and Mrs. Bernard H. Wittenberg

Lever painted all types of nautical vessels, ranging from the fishing boats of St. Ives and the schooners of Gloucester, Massachusetts, to the sailboats and yachts of Nantucket. He also portrayed river traffic along the Hudson, as illustrated in this depiction of a steam-powered ferry boat leaving the Lackawanna Railroad slip in Hoboken, New Jersey, on its way to the West Twenty-third Street terminal in New York City. Although ferryboats going between Manhattan, Brooklyn, and New Jersey were a common sight on New York's waterways during the nineteenth century, the construction of bridges and tunnels linking the boroughs eventually led to their demise. The Lackawanna Ferry was one of the more long-lived of the local ferry services, operating from 1905 until 1947.[1]

Lever combines his penchant for painting boats with a romantic interpretation of the modern city, shown in the distance as if covered by a diaphanous veil of atmosphere, its mighty towers of commerce silhouetted against a muted, overcast sky. The emphatic, agitated brushwork in the foreground is typical of Lever's later work, although here, it gives way to a gentler, more uniform handing in the background. The artist's technique, coupled with his predominantly cool palette, creates soft, atmospheric effects in the distance and contributes to the poetic mood that permeates the image. The painting functions as an homage to both New York City and its waterways, subjects of endless appeal to Lever and ones that he explored under varying conditions of light and air.

1. For an overview of New York's ferries, see Arthur G. Adams's entry in *The Encylopedia of New York City,* edited by Kenneth T. Jackson (New Haven, Conn.: Yale University Press, 1995), 397–401.

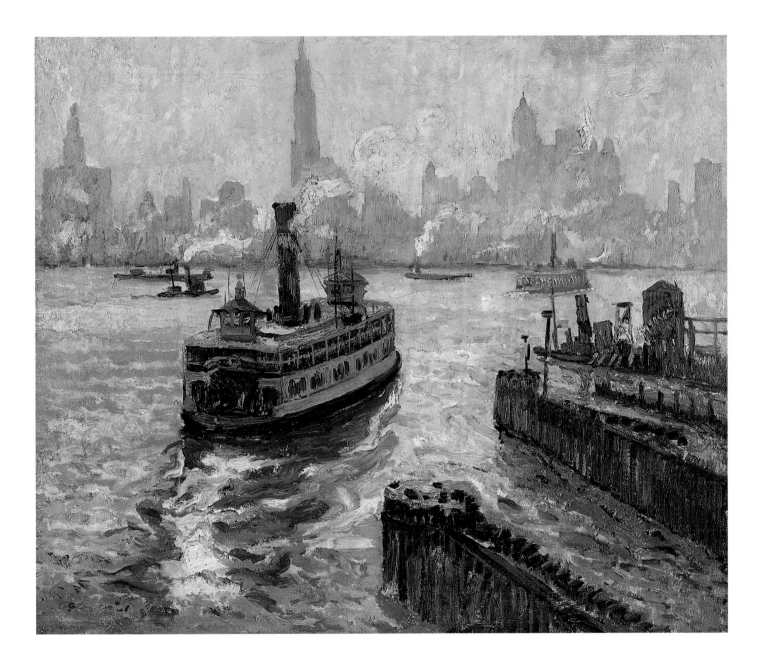

28.

Sea and Rocks in Moonlight, Brant Rock, Massachusetts, ca. 1920s–30s

Oil on canvas
20 × 24 inches
Signed lower right: *Hayley Lever*

Lever's interest in nocturnal subjects stemmed from his contact with the British Impressionist Julius Olsson, a specialist in moonlit seascapes. So inspired, he went on to paint his own night-time marines, depicting littoral scenery in southwest England, Australia, and the United States. In this canvas, he adheres to a minimalist design, presenting us with an open vista of the chilly Atlantic as seen off the coast of Brant Rock, in southeastern Massachusetts. A pale moon sits high in the sky, casting a trail of golden light that extends from the three-masted schooner on the horizon across the face of the water to the cluster of rocks and foam-crested waves in the foreground.

Lever describes the pulsating surface of the ocean with vivacious brushwork that implies ever-changing movement and energy and that acts as a foil to the smoother, more uniform handling of the sky. His palette features green, brown, black, glistening yellow, and white, all of which are subordinated to the array of sensuous blues that reveal the artist's talent for manipulating gradations of tone. Lever's signature, in bright red, adds an expressionistic flourish to this highly subjective vision of the sea.

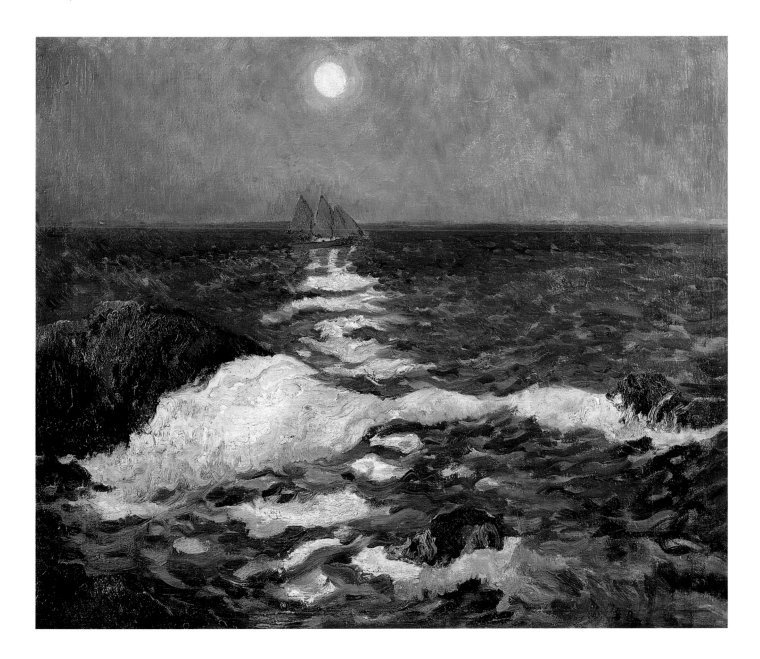

29.

At the Pier, Nantucket, ca. 1920s–30s

Oil on canvas
16 × 20 inches
Signed lower right: *Hayley Lever*

Known as an artist of versatility and independence, Lever embraced a variety of stylistic approaches, ranging from a subtle Impressionist mode to a decorative, Post-Impressionist manner. Influenced by the example of Vincent van Gogh, whose colorful and boldly rendered paintings he saw on a trip to the Continent in 1908, Lever also worked in an expressionist vein, as revealed in this vibrant portrayal of the waterfront in Nantucket, the remote island off the coast of Massachusetts. Adhering to a carefully articulated design, Lever divides the scene into distinct areas of water and sky, bisected by the fishing boats clustered along the quay, their tall masts soaring into a blue sky with scudding clouds.

Employing a palette dominated by fresh blues and greens, Lever describes the foreground with gestural brushwork that, along with the heavily encrusted paint surface, captures the ceaseless movement and energy of the sea, suggests the vibratory sensations of sunlight, and infuses the image with intricate patterning that prevents our gaze from lingering on any single spot. He applies an equally vigorous handling in rendering the boats, interpreted with thick, slashing strokes, and the clouds, translated as broad shapes hovering in the sky.

Certainly, Lever's use of pure color and his vivacious technique reveal his assimilation of modern tendencies in painting, underscoring, in particular, the lingering impact of van Gogh. However, the canvas has emotional meaning as well, for it represents Lever's joyous reaction to the aesthetic delights of Nantucket, which, in his opinion, was "among the most beautiful and distinctive places...in which to paint."[1]

1. Quoted in "Noted Maritime Painter Here," unidentified newspaper clipping, ca. 1933, Richard Hayley Lever Publicity Book, Clayton-Liberatore Gallery, Bridgehampton, New York.

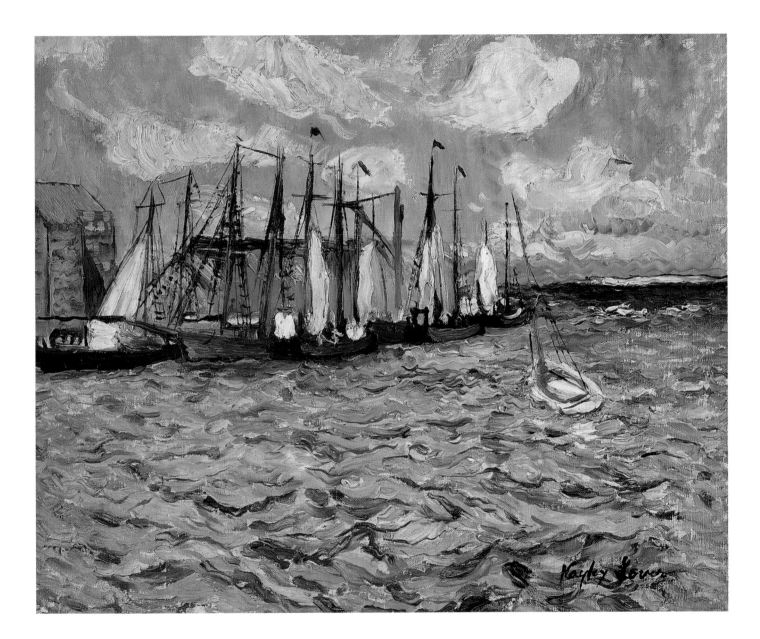

30.

A Cottage in West Caldwell, New Jersey, 1932

Oil on canvas
20¼ × 24¼ inches
Signed lower right: *Hayley Lever*
Inscribed and dated on stretcher:
 "A Cottage in West Caldwell, N.J. 1932"

Lever painted in New Jersey as early as 1912, but it was not until he moved to the town of Caldwell that views of the state figured prominently in his iconography. During the years he lived there— from about 1930 to 1938—he painted marines along the New Jersey shore, as well as a number of landscapes. Many of the latter were done in and around Caldwell, among them this portrayal of a bungalow flanked by a well-tended flower garden, dense shrubbery, and tall trees. That Lever should be attracted to the theme of the floral environment is not surprising, for in a questionnaire he filled out for the National Academy of Design, he listed gardening as one of his recreational activities.[1]

Lever typically varied his style to accord with his subject matter and the type of mood and effect he wished to convey. In this canvas, his brilliant chromaticism harks back to his earlier exposure to the paintings of Vincent van Gogh and suggests, as well, a link with the exuberant colorism of such School of Paris painters as Maurice Utrillo. His use of broken brushwork in depicting the setting reveals a debt to Impressionism, including the work of American practitioners of that style, such as John Henry Twachtman, an artist he is known to have admired,[2] who also investigated the theme of home grounds and gardens.[3]

As always, Lever exploits the design possibilities of the architecture, using dark outlines to differentiate the varied components of the cottage and to create a powerful sense of structure that contrasts with the natural surroundings. Spontaneity and verve are the keynotes of this painting, which is as much about form and color as it is a vision of domestic life in suburban New Jersey.

1. See Richard Hayley Lever file, National Academy of Design, New York.

2. As noted in Cheryl A. Kempler, *Hayley Lever (1876–1958): Works in Various Media*, exh. cat. (Wilmington, Del.: Delaware Art Museum, 1978).

3. For this topic in relation to American Impressionism, see Lisa N. Peters et al., *Visions of Home: American Impressionist Images of Suburban Leisure and Country Comfort*, exh. cat. (Carlisle, Pa.: Trout Gallery, Dickinson College, 1997).

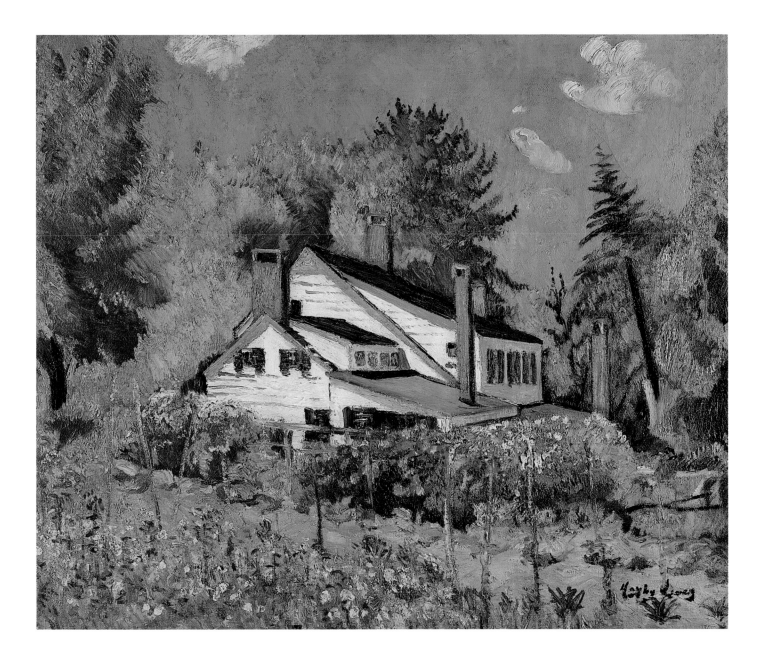

31.

The Sea with a Kick, Rounding the Cape of Good Hope, 1932

Oil on canvas

30 × 40 inches

Signed and dated lower right: *Hayley Lever / 1932*

Signed and inscribed on verso: *The / Sea / with / a Kick / Hayley / Lever / 116 E. 66th N.Y.C.*

By and large, Lever's marines are populated by wind-tossed sailboats, yachts, and fishing vessels. In this instance, however, he presents us with a "pure" seascape, focusing exclusively on the natural elements of water, wind, and air. Painted in 1932, the work was presumably inspired by his memories of his earlier voyages between Adelaide, Australia, and England, the first of which took place about 1894, when he sailed to England to commence his formal training as an artist.[1] Lever later reminisced about that journey, stating: "the crossing from Australia was no joke in those days. The trip took a month."[2] He made a second passage in 1904, when he returned to Adelaide, with a stop at Capetown, South Africa, for an extended stay that lasted into 1905.

Lever's reductive composition is divided almost evenly between the churning ocean and a broad expanse of sky. A few gulls can be seen on the left, their dark forms profiled against a patch of storm clouds bisected by the arc of a rainbow. Intent on translating the turbulent motion of the sea into paint, the artist portrays his subject with an impressionistic technique, employing loose, fluent strokes to represent the water while turning to a more uniform, controlled touch in the sky. The deep indigo blues of his palette are accompanied by iridescent pinks, mauves, greens, and accents of white that convey the play of sunlight as it falls across the agitated ocean.

1. This may be the work Lever exhibited at the National Academy of Design's winter exhibition in 1932, under the title *Rounding Cape of Good Hope*.

2. "Paris in Jersey Found in Home of Caldwell Artist," *Newark Evening News*, 14 August 1936.

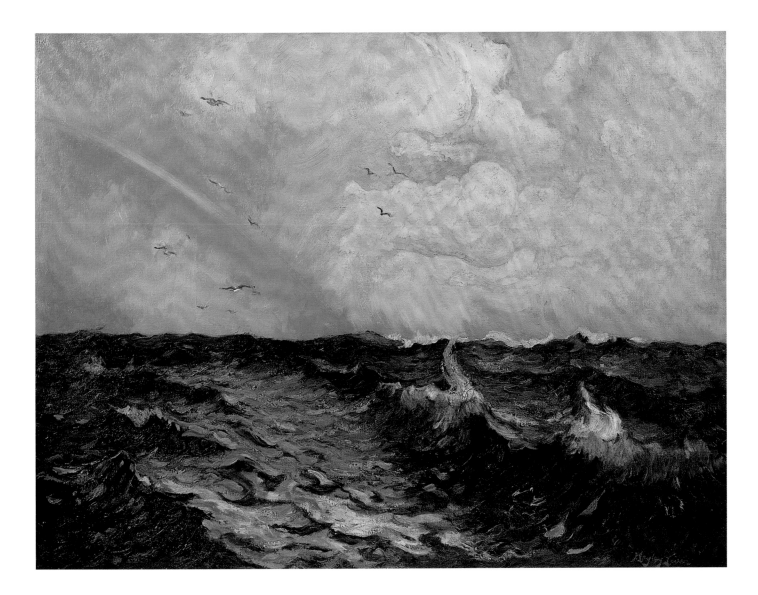

32.

Spring Landscape, ca. 1930s

Oil on canvas
24 × 36 inches
Signed lower right: *Hayley Lever*

The stylistic diversity of Lever's art is exemplified by this view of inland America. It was executed late in his career, when, suffering from emotional anxiety caused by financial setbacks experienced during the Depression, his paintings took on expressionistic overtones that hark back to his early exposure to the work of Vincent van Gogh. This tendency is apparent in the somewhat exaggerated rendering of the dilapidated farm buildings and the tall grasses, but is seen most vividly in the portrayal of the large, blossoming fruit tree on the right, whose outstretched, tentacle-like branches assume a life of their own and impart an overt linearity to the image. A powerful feeling of animation also permeates the canvas—indicative not only of Lever's personal state of mind but symbolic of the stirring of nature and the growth and vitality associated with the onset of spring.

Probably inspired by the artist's treks into the countrysides of New Jersey, Vermont, and New York, the rural subject and graphic—almost magical—realism that distinguishes this canvas links Lever with American Scene painting of the 1930s.

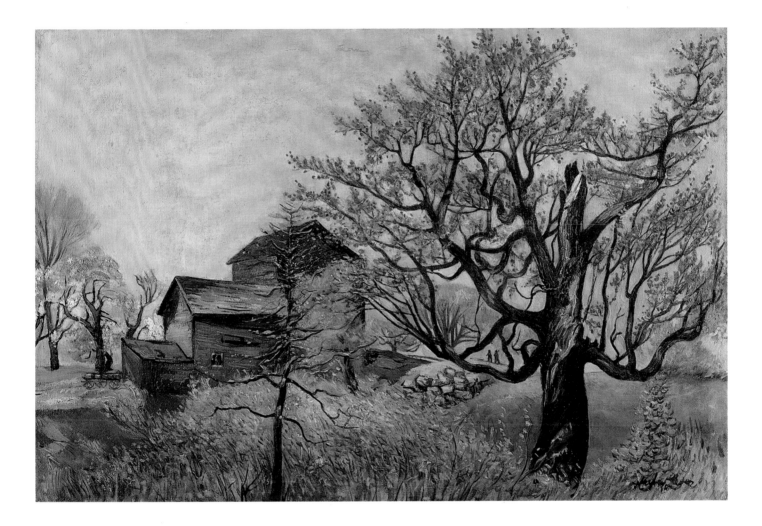

33.

Belleville, New Jersey, ca. 1935

Oil on canvas
20¼ × 24½ inches
Signed lower right: *Hayley Lever*

Following his move to Caldwell, New Jersey, about 1930, Lever painted in various parts of the state, drawing inspiration from its coastline and waterways and from communities such as the township of Belleville, situated just to the north of Newark in Essex County. It was there that he produced this townscape featuring houses nestled comfortably around the Dutch Reformed Church at 171 Main Street, as seen across the placid waters of the Passaic River on a summer's day.[1] Once known as the Second Reformed Church at Second River, the congregation was established around 1697–98 by Dutch settlers, making it the oldest congregation still functioning in New Jersey today. The stately edifice depicted in Lever's image was erected in 1863, a Gothic-revival style building designed by the architect William Kirk.

Adhering to a stylistic approach that draws on both the realist and impressionist aesthetics, Lever applies his paint in a free and breezy manner, eschewing detail in favor of a summary yet very decisive technique that works effectively with his well-structured design. His portrayal of the foreground is especially striking, his divisionist brushwork capturing the ebb and flow of the river as well as the reflections of glistening sunlight on its surface. Indeed, in *Belleville, New Jersey* Lever conjoins his fascination with water with a concern for rendering the regional landscape. In this case, he pays his respects to small-town New Jersey and in so doing provides us with an engaging vision of peace and tranquillity.

1. I would like to thank Frederick Lewis, librarian at the Belleville Public Library, for identifying the church. For the history of the Dutch Reformed Church in Belleville, see *300th Anniversary: 1697–1997* (Belleville, N.J.: Belleville Reformed Church, 1997).

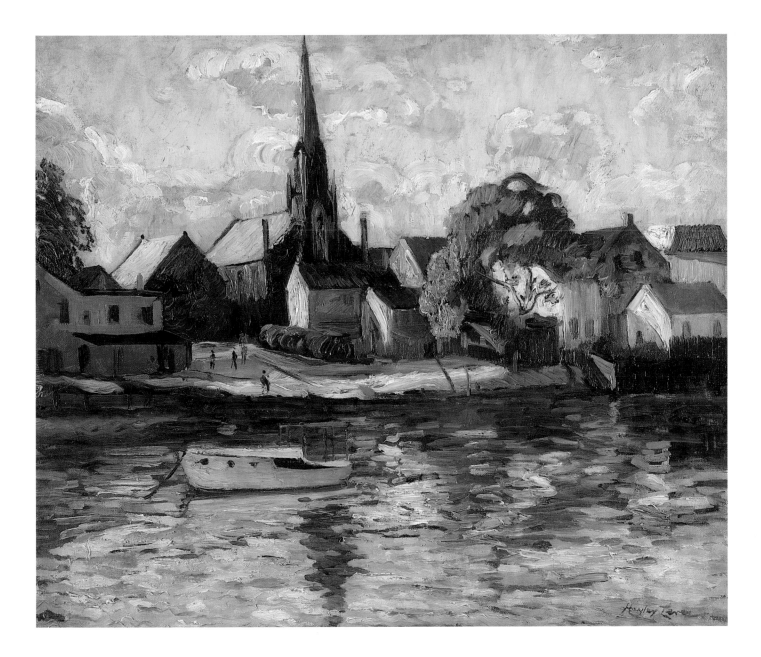

34.

East River, 1938

Watercolor on paper
14 × 19 inches
Signed lower right: *Hayley Lever*
Inscribed lower right: *East River*

Lever painted many watercolors of New York, including this depiction of the Queensborough Bridge, which spans the East River between Fifty-ninth Street in Manhattan and Long Island City in Queens. A steel, two-level cantilevered structure designed by Gustav Lindenthal in 1903 and completed in 1909, the Queensborough Bridge crosses over Roosevelt Island (in Lever's day, known as Welfare Island), which appears on the right-hand side of the composition.[1] Also referred to as the Fifty-ninth Street Bridge, the 7,450 foot bridge featured decorative ironwork by the architect Henry Hornbostel. Viewed today as one of the city's landmarks, it was the third of eight bridges constructed across the East River.

Lever's watercolors typically sparkle with color; however, in this example he restricts his palette to black, which vividly stands out against the cream-colored support. Working in a style that is both expressive and naturalistic, he articulates the bridge, the solitary boat, and portions of the waterfront with firm, opaque lines and an array of dots, daubs, and dashes, while turning to soft, pale washes to denote the wispy clouds and the more subtle ripples and reflections in the water. The end result is a powerfully graphic image—one that demonstrates Lever's keen observation and expert command of watercolor, as well as his enduring attraction to the modern metropolis.

1. An inscription on the verso of the painting states, incorrectly, that the bridge portrayed is the Tri-Borough Bridge. I would like to thank John Driscoll of the Queens Historical Society for his assistance in identifying the structure as the Queensborough Bridge. According to Driscoll, the large building on the right was likely one of Welfare Island's several hospitals.

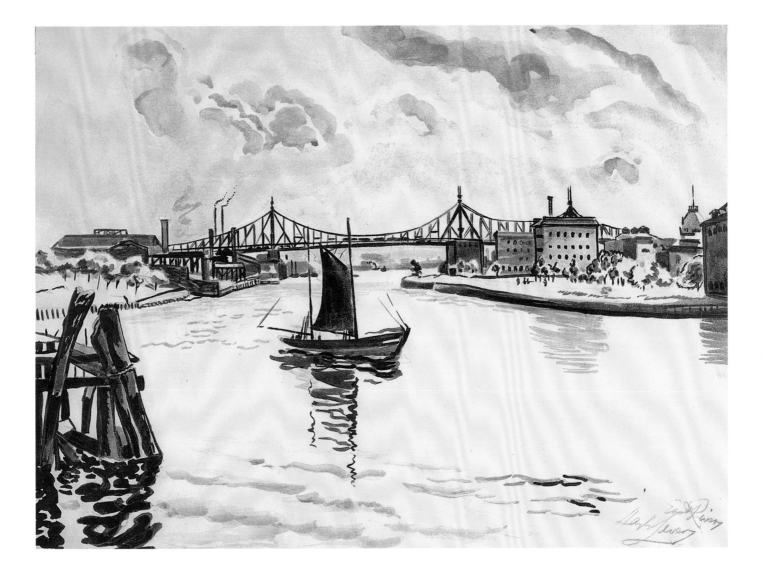

35.

Returning Fishermen—The Jetties, Manasquan, New Jersey, 1938

Oil on canvas
30 × 36 inches
Signed and dated lower right: *Hayley Lever / 1938*

A painter who specialized in the "theme of little boats bobbing up and down in wind-stirred waves," Lever drew inspiration from a variety of littoral locales, ranging from the shorelines of southern Australia and St. Ives, England, to the harbors of Massachusetts.[1] He was also active in coastal New Jersey. Indeed, during the years 1930-38, when he lived in Caldwell, Lever made frequent painting excursions to the New Jersey shore, to fishing towns such as Manasquan, where he painted this striking portrayal of a fleet of shrimp boats. Riding low in the water, the vessels nod and dip in the churning sea as they make their way toward home port.

Lever was a resourceful painter who explored a variety of styles. Late in his career, he often turned to reductive compositions and expressionistic brushwork, although his concept of nature continued to be rooted in realism. He takes such an approach in the present work, dividing the image into distinct areas of water, land, and sky, the diagonals created by the waves and shoreline in the foreground acting as foils to the line of rocks extending into the sea and to the narrow horizon line in the distance.

Lever's starkly minimalist design imbues the scene with a near-abstract quality that is enhanced by the broadly conceived forms. His rendering of the pounding surf in the foreground is especially striking. To be sure, Lever's bold handling evokes the movement and thrust of an agitated ocean, while his thick application of pigment creates lush surface textures and underscores his innate feeling for his medium. The artist complements his pared-down composition with a limited palette dominated by cool blues, greens, grays and white, all of which convey the glow of pale sunlight emanating from a muted sky.

Notable for the simplicity and vigor of its conception, *Returning Fishermen—The Jetties, Manasquan, New Jersey*, reminds us that Lever was as much concerned with form and design as he was with capturing nuances of light and atmosphere. The canvas also attests to the fact that he was first and foremost a painter of marines. It is in this realm that Lever achieved his finest pictorial accomplishments, impressing his audiences with what one commentator aptly referred to as his "breadth of vision and wide knowledge of sea and sky, and many varieties of boats."[2]

Exhibited as *Sea Scape* at the annual exhibition of the National Academy of Design in 1938, *Returning Fishermen—The Jetties, Manasquan, New Jersey* received the Edwin Palmer Memorial Prize for marine painting. The honor marked a triumph for Lever, for it broke what one contemporary commentator called the "precedent which has usually given that award to more naturalistic transcriptions."[3]

1. Duncan Phillips, *A Collection in the Making* (Washington, D.C.: Phillips Memorial Gallery, [1926]), 58.

2. "Hayley Lever at Macbeth's," *American Art News* 18 (27 March 1920): 2.

3. "Around New York," *Magazine of Art* 31 (May 1938): 299.

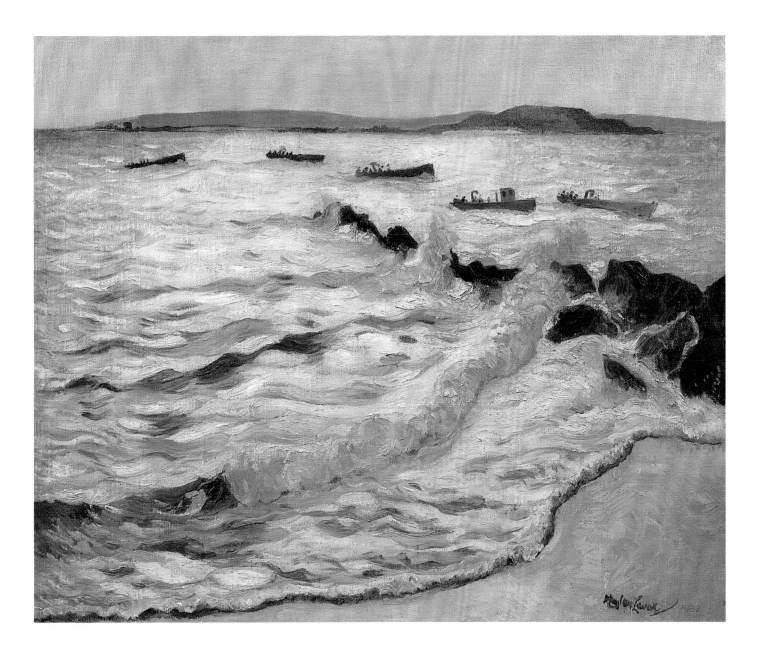

36.

City Island, New York, ca. 1930s–40s

Oil on panel
12 × 16 inches
Signed lower left: *Hayley Lever*
Signed and inscribed on verso: *City IS NY / Hayley Lever*

Lever's affinity for maritime subjects first surfaced during his years in St. Ives, on England's Cornish seacoast. He continued to paint boats and sea following his move to America, drawing inspiration from littoral scenery in places such as Gloucester Massachusetts, and Monhegan Island, Maine. His interest in nautical themes also took him to the outer boroughs of Manhattan, as revealed in this dynamic portrayal of sailboats along the shores of City Island.

That Lever should be attracted to City Island is not surprising, for it was a peaceful, somewhat isolated landmass situated in the northeastern section of the Bronx. Most importantly, it provided him with the motifs he loved to paint. Indeed, at the turn of the century, City Island emerged as an important center for the building of yachts, with many prominent tycoons and business-men mooring their boats there. In addition to boat building and sail making, the island also emerged as a summer resort, boasting comfortable cottages and lively marinas.

One of the striking features of this plein-air panel painting is its dynamic composition, in which Lever depicts the vessels close-up on the picture plane, a strategy that imbues the work with a vital sense of immediacy. This effect is enhanced by his use of bold, thickly applied strokes of paint to define form and evoke the fleeting effects of sunlight as it falls on the boats and water. Lever combines his summary handling with a striking palette, expertly conjoining cool blues and greens with hot pink and an array of buff tones and white. Nimble touches of black add further verve and animation to the image, giving it a distinctive calligraphic quality and reminding us that Lever "knows the ways of skimming boats and bright waters and sets them down with authority."[1]

1. "Hayley Lever, Joseph Szekely: Balzac Galleries," *Art News* 30 (26 December 1931): 10.

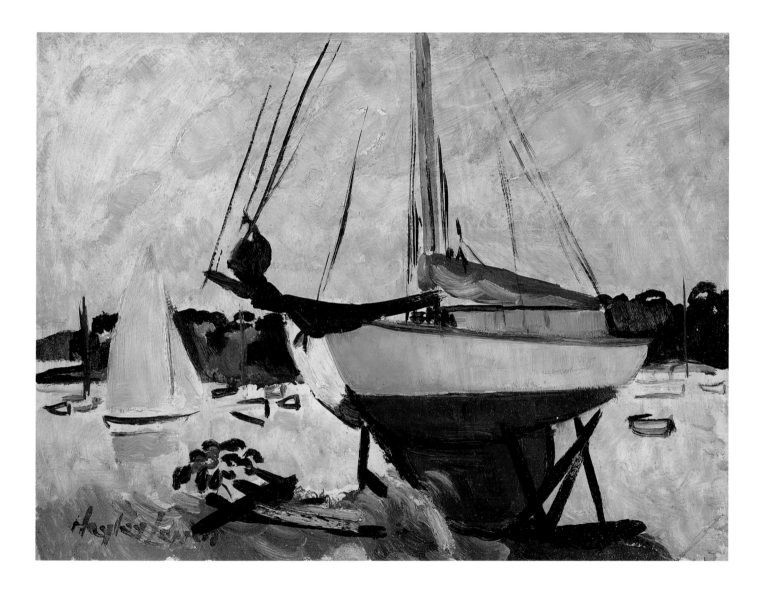

37.

Approaching a Farm, ca. 1930s–1940s

Oil on canvas
30 × 36 inches
Signed lower right: *Hayley Lever*

Lever's work became more expressive and personal during the 1930s, due in part to the financial problems he experienced as a result of lack of sales during the Great Depression, which had a marked effect on his sense of well-being. At the same time, he had always kept an open mind when it came to matters of style, refusing to link himself with any particular "school" or "ism." In his opinion, an artist must develop his own personality—a point he emphasized in his classes, telling his students: "Paint like you write or paint like you talk. If one is rotten, don't be ashamed of it. Serious attempts are worth more than imitations."[1]

Lever transmitted his turbulent mental state to many of his canvases during this period, as demonstrated in *Approaching a Farm*, which features ominous storm clouds hovering over a farmhouse and its surrounding pastureland. A dead tree stands at the fork of the road in the foreground, an anomaly in an otherwise lush landscape. Indeed, its twisting, writhing branches give it a personality all its own, suggesting the indelible powers of nature and, probably, Lever's own feelings of unease and anxiety. Although the subject matter is recognizable, the artist's exaggerated, caricature-like distortions of form, his harsh contrasts of light and dark, his unruly brushwork, and his electric colors take the work beyond mere representation, into the realm of fantasy and the symbolic.

1. Quoted in Cheryl A. Kempler, *Hayley Lever (1876–1958): Works in Various Media*, exh. cat. (Wilmington, Del.: Delaware Art Museum, 1978), 15.

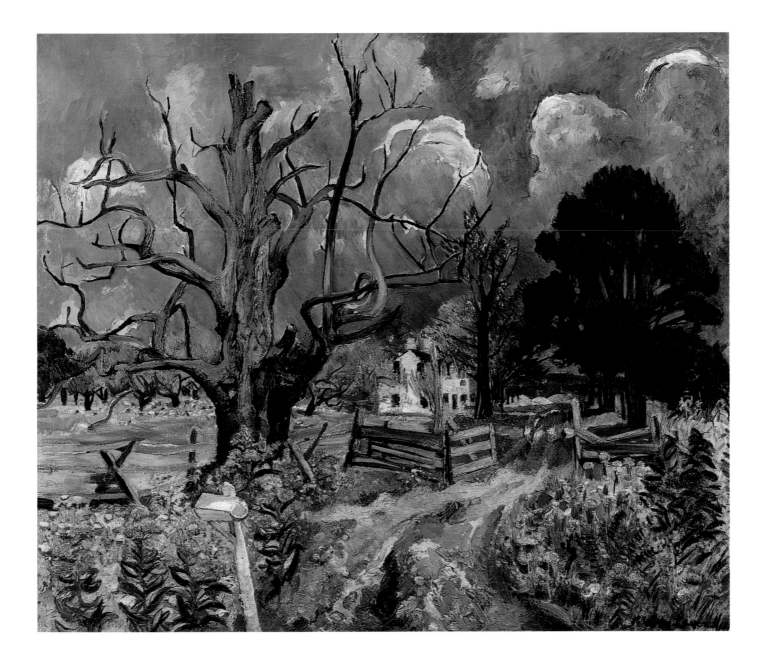

38.

Irises in a Glass Bowl, ca. 1940

Oil on canvas mounted on board
20½ × 32½ inches
Signed lower left: *Hayley Lever*

In addition to painting marines, landscapes, and the urban envi-
ronment, Lever investigated the venerable subject of still life, a
theme he began exploring during the early 1900s while living in
England, and one that he pursued for the remainder of his
career. Still life became a special preoccupation during the last
two decades of his life, when bouts of arthritis prevented him
from traveling to his usual summer haunts to work outdoors. On
a deeper level, Lever considered still-life painting an essential
component of his art, for it allowed him to combine the study
and observation of nature with pictorial concerns relative to
form, color, and design and his own subjective feelings.

Lever's still lifes include arrangements of fruit, vegetables, fish,
and other edibles. However, as observed by a New York critic in
1915, the artist definitely showed "an appreciative eye and deft
hand for floral pieces."[1] Indeed, Lever preferred painting still lifes
of flowers, favoring sprays of spring and summer blossoms set in
a vessel and shown close-up on the picture plane, as is the case
with this depiction of colorful flowers—stately *Iris Germanica*—
in a glass bowl.

Lever often incorporated aspects of Vincent van Gogh's style
into his work, but his link with that artist's aesthetic was particu-
larly strong toward the end of his life, when he began to make
greater use of agitated brushwork and vibrant chromatic con-
trasts—tendencies found in *Irises in a Glass Bowl*. Working with a
fully loaded brush, he forcefully models the blossoms and spear-
like leafage, conceiving them as simplified, rhythmic shapes with
firmly defined contours. The expressivity that typifies his late
work is apparent in his representation of the backdrop, described
with short, directional strokes of paint that seemingly flow out-
ward from the bouquet, as if to imply energy, movement, and
flux, as well as an aura of light. The artist's palette, with its dynamic
interplay of high-keyed yellows, deep greens, purples, maroons,
and white, works with his robust handling to make a powerful
visual statement—one that suggests the intensity of the artist's
response toward his subject matter and epitomizes his belief that
"Art is the re-creation of mood in line, form and color."[2]

1. "News of the Art World, *World* (New York), 10 January 1915, p. 3.
2. Quoted in Cheryl A. Kempler, *Hayley Lever (1876–1958): Works in Various Media*, exh. cat. (Wilmington, Del.: Delaware Art Museum, 1978), 14.

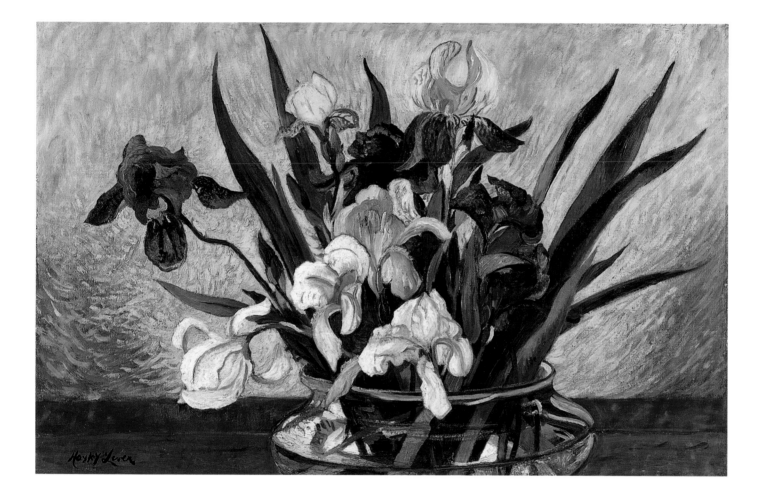

39.

Sailboat in a Park Lake, ca. 1920s–40s

Oil on canvas mounted on board
9⅞ × 14¼ inches

Lever's oeuvre is replete with depictions of pleasure boats, skimming the shores of coastal locales such as Nantucket, or, as in the present work, gliding along the quiet waters of an inland lake. Possibly intended as a preliminary study for a larger oil, *Sailboat in a Park Lake* is notable for its animated handling and the solidity and decorative stylization of its forms, as well as its dense application of pigment, which produces a rough, heavily encrusted surface. The artist's skillful balancing of light and dark hues helps convey the clear, brisk atmosphere of a sunlit summer's day, while his expressive technique—a hallmark of Lever's late aesthetic—suggests his own inner passions.

40.

Lilies-of-the-Valley, ca. 1930s–40s

Oil on panel

14 × 10 inches

Signed lower left: *Hayley Lever*

Lever's enthusiasm for flower painting is evident in this picture of a spray of lilies-of-the-valley in a glass vase. As in other examples of his work in this genre, he situates the grouping in a shallow space, the white florets standing out against wallpaper decorated with sinuous arabesques.

The artist's debt to the pictorial language of Post-Impressionism is demonstrated by his technique, in which pigment is applied with broad, forceful strokes that imbue the image with vitality. The well-articulated composition and the dark contours appearing on the leafage suggest the impact of Vincent van Gogh and work with the ornate backdrop and the tiny, bell-shaped flowers to create a vivid sense of patterning. Lever's still lifes were often brightly colored, as in *Irises in a Glass Bowl* (Cat. 38), but in this instance he adheres to a less strident chromaticism, his juxtaposition of cool lavenders, blues, and greens with warm shades of orange and red indicating an effective use of complementary color contrasts.

The lily-of-the-valley is a sweetly-scented blossom associated with springtime, delicacy, and the return of happiness.[1] However, Lever would have chosen this motif not for its symbolic content, but for the infinite possibilities it offered in terms of exploring matters of form, color, and design.

1. Beverly Seaton, *The Language of Flowers: A History* (Charlottesville, Va.: University Press, of Virginia, 1995), 182–83.

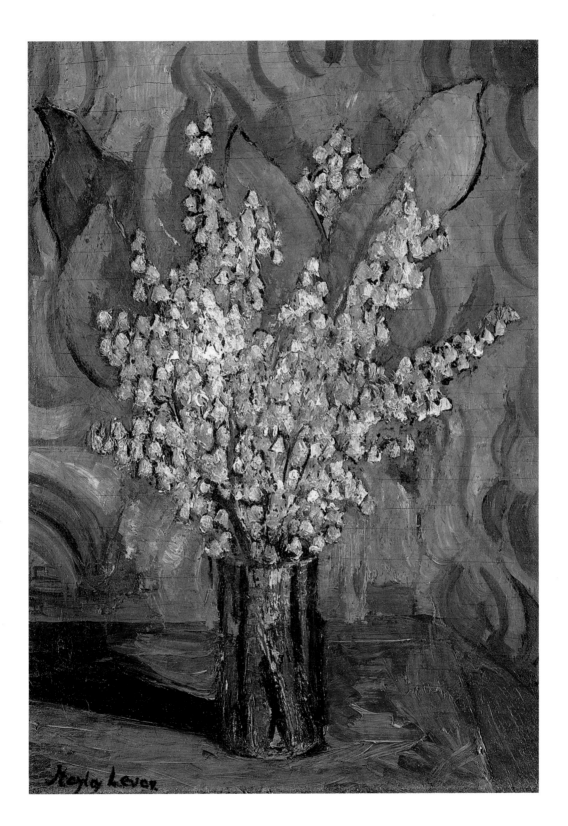

Chronology

1876

Born 28 September in Bowden Tannery, a suburb of Adelaide, Australia, son of English parents, Albion W. Lever and Catherine (Hayley) Lever. He was christened Richard, but as a professional artist, he used his second and last names only.

1883–91

Attends Prince Alfred College, a private secondary school in Adelaide, where he receives drawing lessons from the English-born marine painter James Ashton.

1891–93

Attends Ashton's Academy of Arts in Adelaide. Paints and sketches in the local countryside. Grandmother sets aside a room in her house where he could paint.

ca. 1894–95

Travels to London to study art with funds inherited after the death of his grandfather, Richard Hayley, an affluent business-man who operated the Bowden Tannery. On a visit to the National Gallery, sees paintings by Piero della Francesca and is inspired by his sense of color, design, and composition.

mid-late 1890s

Spends two winters studying figure painting in Paris probably with René-François-Xavier Prinet.

ca. 1899

On the advice of James Ashton, goes to St. Ives, a fishing port and artists' colony on England's Cornish seacoast. Studies plein-air painting techniques with the British Impressionist painters Julius Olsson and Algernon Talmage. Resides at 14 Carrack Dhu; establishes studio on the top floor of Lanham's Gallery.

1900–11

Paints views of the town and harbor of St. Ives and its environs, as well as scenes of Devon. Makes painting excursions to coastal locales in France, including Dieppe, Honfleur, Concarneau, Douarenez, and Ile de Groix. Exhibits at the St. Ives Art Club, the New English Art Club, the Royal West of England Academy, the Royal Academy of Arts, and the Society of Royal British Artists. Participates in exhibitions in Paris, Nice, and Venice.

1904

Makes his debut at the Royal Academy of Arts with *Eventide, St. Ives Harbour*.

1904–05

Visits Paris and then returns to Adelaide on the SS *Mersee*, with a stop at Capetown, South Africa. Spends six months painting colorful, Impressionist-inspired coastal scenes in Adelaide and Victor Harbor and teaches. Returns to England on the SS *China*.

1906

Marries Aida Smith Gale in St. Ives Parish Church.

1907

5 August—A son, Richard, is born.

1908

On a trip to the Continent, visits France, Holland, and Belgium. Sees the work of Vincent van Gogh and is deeply influenced by his expressive style. Paints a series of canvases called *Van Gogh's Hospital, Holland*. Elected a member of the Royal Society of British Artists.

1910

By special invitation, exhibits *Port of St. Ives, Cornwall* at the Carnegie International in Pittsburgh. Exhibits there inter-mittently until 1946.

1912

At the suggestion of several American painters he had met in St. Ives, Lever comes to the United States. Departs Liverpool on 21 September on the *Winifredian*; arrives in Boston, 29 September. Settles in New York and begins sketching and painting the streets, parks, and waterfront of Manhattan. Fraternizes with a group of artists that includes the Impressionists Ernest Lawson and Gardner Symons and the New York Realists Robert Henri, John Sloan, and George Bellows.

1913

Awarded Honorable Mention at the Carnegie Institute Annual for *East River, New York*. Decides to remain permanently in the United States. Elected an artist life member of the National Arts Club, New York.

1914

Awarded the National Academy of Design's Carnegie Prize for *Winter, St. Ives*. Awarded the National Arts Club's Silver Medal for *The Harbor at St. Ives* (alternative title: *Fishing Boats, St. Ives, Cornwall*). *Exhibition of Paintings by Mr. Hayley Lever of Cornwall, England* held at the Memorial Art Gallery, Rochester, New York, 11–30 September, followed by *Exhibition of St. Ives Paintings* at the Syracuse Museum of Fine Arts, 1 November–1 December.

1915

January—Solo exhibition of St. Ives scenes and New York City subjects at the City Club, New York. January—Exhibits at the Macbeth Gallery in New York for the first time: *A Group of Selected Paintings*. Exhibits at Macbeth's for over two decades in both one-man and group shows. Awarded National Arts Club Gold Medal for *Dawn, St. Ives* (Corcoran Gallery of Art, Washington, D.C.). Summer—Makes first visit to Gloucester, Massachusetts, where he paints harbor scenes and teaches painting and sketching classes. Exhibits *St. Ives Fishing Boats* in the American section of the *Panama-Pacific International Exposition* and wins a Gold Medal. October—Solo exhibition, *Oils and Watercolors by Hayley Lever*, held at the Macbeth Gallery.

1916

March—Solo exhibition at the Daniel Gallery in New York. Awarded Gold Medal at the National Arts Club for *Early Morning at St. Ives*. September—Participates in the inaugural exhibition of the Gallery-on-the-Moors in Gloucester.

1917

March—*Exhibition of Recent Paintings by Hayley Lever* held at the Daniel Gallery. Awarded the Jennie Sesnan Gold Medal at the Pennsylvania Academy of the Fine Arts for *Morning in the Harbor*. *Exhibition of Works by Karl Anderson, Hayley Lever, Ernest Lawson and Leopold Seyffert* organized by the Detroit Museum of Art and circulated to five other museums, 1917–18.

1918

April—Solo exhibition at the Daniel Gallery. Becomes a charter member of the Whitney Studio Club. Wins the Philadelphia Water Color Club Prize.

1919

Joins the Art Students League in New York as a painting instructor and retains that position until 1931.

1920

A Group of Paintings by Ben Foster, Robert Henri, Hayley Lever, and Gardner Symons held at the Macbeth Gallery, 18 October–8 November. December—*Paintings and Etchings by Hayley Lever* held at the Buffalo Fine Arts Academy, Albright Art Gallery.

1920s

Spends winters in New York City and summers in New England painting locales such as Gloucester, Marblehead, and Nantucket. Extant paintings also indicate visits to Florida, the Bahamas, and Bermuda.

1921

January—*Paintings and Etchings by Hayley Lever* held at the Toledo Museum of Art; also shown at the Memorial Art Gallery, Rochester, New York, the Syracuse Museum of Fine Arts, and possibly other venues. August–September, *Exhibition of Etchings of Gloucester* held in Gloucester, Massachusetts [venue unknown]. Becomes a naturalized American citizen; the painters George Gardner Symons and Ben Foster act as witnesses and attest to his "good moral character."

1922

January—Awarded Fourth Prize at the National Arts Club for *Fresh Breeze, Moonlight.*

Paintings by Frederick C. Frieseke and Hayley Lever held at the Macbeth Gallery, 27 April–20 May. Teaches at the Arts Students League's summer school in Woodstock, New York.

1923

October—Exhibits a selection of etchings at Schertse Studios, Boston.

1924

February—*Exhibition of Oils and Water Colors* held at Anderson Galleries, New York. *Special Exhibition of Thumb Box Sketches, Water Colors, Etc. by Hayley-Lever* held at the Corcoran Gallery of Art, 21 April–4 May. Receives commission to paint the presidential yacht, "Mayflower." The canvas is eventually presented to President Coolidge in the Cabinet Room of the White House.

1925

Elected an associate member of the National Academy of Design (A.N.A.). April—Solo exhibition at the Milch Galleries, New York. *Exhibition of Paintings by Hayley Lever* held at the Art Students League, New York, 13–18 April.

1926

Awarded Gold Medal at the Pennsylvania Academy of the Fine Arts for *The Harbor* and Bronze Medal at the Sesquicentennial International Exposition for *Morn in the Harbor, St. Ives, Cornwall.*

1927

Summer—Travels to Europe on the SS *Minnekahda.* Spends two weeks in Cornwall. Visits Paris, Normandy, and Brittany. Returns to New York with a group of early paintings done in St. Ives, which he exhibits at Macbeth's in 1928.

1928

April—Solo exhibition, *St. Ives by Hayley Lever, A.N.A.,* held at Macbeth Gallery. Summer—Awarded Bronze Medal at Ninth Olympiad in Amsterdam for *Regates.* December—Awarded the J. Frederick Talcott Purchase Prize at the *Small Paintings Exhibition* held at the National Arts Club.

1929

March—Solo exhibition, *Oil Paintings, Water-Colors and Prints by Hayley Lever,* held at the Syracuse Museum of Fine Arts. April—*Exhibition of Paintings by Hayley Lever* held at the Art Gallery of Toronto. December—Solo exhibition at the Milch Galleries. Starts exhibiting at the Clayton-Liberatore Gallery in New York.

ca. 1930

Moves to 66 Ravine Avenue in Caldwell, New Jersey.

1930

One-man exhibition, *Exhibition by Hayley Lever,* held at the Montclair Art Museum, New Jersey, 15 February–2 March.

1930s

Maintains a studio in New York City, where he paints and teaches Saturday art classes. Also teaches at the Newark Art Club. Paints in rural New Jersey, New York City and environs, Long Island, and Vermont. Sells little work during the Depression but continues to win recognition in the national annuals.

1930–31

Teaches at the Art Students League's summer school in East Gloucester, Massachusetts.

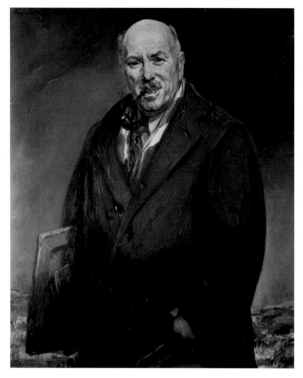

Fig. 14.
Raymond Perry Rodgers Neilson (1881–1964), *Hayley Lever*,
1938, oil on canvas, 36 × 30⅛ in., National Academy of
Design, New York, Gift of the estate of Raymond P. R. Neilson,
1964 (1652-P).

1931

March/April—Solo exhibition at G. R. D. Studio, New York. Solo
exhibit, *Seascapes by Hayley Lever,* held at the Balzac Galleries,
New York, December 1931–4 January 1932.

1933

Elected an academician of the National Academy of Design
(N.A.). Serves as director of the Green Mountain Summer Art
School, established at Smuggler's Notch in Stowe, Vermont, by
the Art Students League of New York.

1934–35

Teaches painting classes at the Forum School of Art,
Bronxville, New York.

1936

Awarded Edwin Palmer Memorial Prize at the National
Academy of Design for *Nantucket.* Awarded prize at the
Newark Art Club, New Jersey.

1937

March—Solo exhibition, *Hayley-Lever: Paintings—Old and New,*
held at Macbeth Gallery.

1938

Loses his home in Caldwell, New Jersey due to financial reversals.
Moves to Mount Vernon, New York, where he is appointed
director of the Studio Art Club. Awarded the Edwin Palmer
Memorial Prize at the National Academy of Design for *Seascape*
(alternative title: *Returning Fisherman—The Jetties, Manasquan,
New Jersey*).

1940

Travels to Nova Scotia and Grand Manan Island, Canada. Paints
scenes of industrial life on the Hudson River outside New York.
Awarded prize at the National Arts Club's *Exhibition of Flower
and Still Life Paintings* for *Bouquet.*

1940s

Turns increasingly to still-life subjects when debilitating arthritis
prevents further travel. Learns to paint with his left hand.

1941

Wins a medal at the New Rochelle Art Association.

1945

Solo exhibition, *Paintings by Hayley Lever, N.A.,* held at the
Ferargil Galleries, New York, 29 October–10 November. Awarded
prize by the Westchester Arts and Crafts Club.

1949

Receives the Robert Adriance Birch Award (Birch was founder
of the Studio Art Club). His wife, Aida, dies in March.

1954

Confined to Crestview Hall, a nursing home in Mount Vernon.

1958

Dies at Mount Vernon Hospital, 6 December.

Hayley Lever—A Selected Bibliography

Manuscript and Archival Sources

Daniel Gallery. Papers. Archives of American Art, Smithsonian Institution, Washington, D.C.

Lever, Richard Hayley. Publicity Book. Clayton-Liberatore Gallery, Bridgehampton, N.Y.

Macbeth Gallery. Papers. Archives of Amerivcan Art, Smithsonian Institution, Washington, D.C.

Milch Gallery. Papers. Archives of American Art, Smithsonian Institution, Washington, D.C.

National Academy of Design, New York. Richard Hayley Lever File.

The National Arts Club. Records, 1898–1960. Archives of American Art, Smithsonian Institution, Washington, D.C.

Books and Exhibition Catalogues

Art Gallery of Toronto. *Catalogue of an Exhibition of Paintings by Hayley Lever … Photographs by Royal Photographic Society.* Exh. cat. Toronto: Art Gallery of Toronto, 1929.

Bernard Black Gallery. *Hayley Lever: Selected Works, c. 1900–1933.* Exh. cat. New York: Bernard Black Gallery, 1967.

Bryant, Lorinda Munson. "Snell, Lever, Yates, Waugh, Dougherty, Koopman." In *American Pictures and Their Painters,* 243–44. New York: John Lane Company, 1920.

Buffalo Fine Arts Academy, Albright Art Gallery. *Catalogue of Four Special Exhibitions: Paintings by Frederick Carl Frieseke, N.A., Paintings by Maurice Fromkes, Paintings and Etchings by Hayley Lever, Paintings by Jonas Lie.* Exh. cat. Buffalo, N.Y.: Buffalo Fine Arts Academy, Albright Art Gallery, 1920.

Clayton & Liberatore Art Galleries. *Hayley Lever: Commemorative Exhibition.* Essay by George Albert Perret. Exh. cat. Bridgehampton, N.Y.: Clayton & Liberatore Art Galleries, 1969.

Clayton & Liberatore Art Gallery. *Hayley Lever, 1876–1958: Etchings: The Complete Set of Eighty-five Plates.* Bridgehampton, N.Y.: Clayton & Liberatore Art Gallery, 1985.

———. *Hayley Lever: Exhibition of Early Oil Paintings of St. Ives, Cornwall, England.* Exh. cat. Bridgehampton, N.Y.: Clayton & Libertore Art Gallery, 1973.

———. *Hayley Lever: Exhibition of "Flowers": Oil Paintings and Watercolors.* Exh. cat. Bridgehampton, N.Y.: Clayton & Liberatore Art Gallery, 1972.

———. *Hayley-Lever: Exhibition of New York City Scenes.* Exh. cat. Bridgehampton, N.Y.: Clayton & Liberatore Art Gallery, 1975.

Clayton-Liberatore Art Studio. *Memorial Exhibition, Hayley Lever, 1876–1958: Watercolors from 1908.* Exh. cat. New York: Clayton-Liberatore Art Studio, 1961.

Corcoran Gallery of Art. *Special Exhibiton of Thumb Box Sketches. Water Colors, Etc. by Hayley Lever.* Exh. cat. Washington, D.C.: Corcoran Gallery of Art, 1924.

David Messum Fine Art. *Now and Then: Painters from West Cornwall in the 1890's.* Exh. cat. London: David Messum Fine Art, 1998.

Flockhart, Lolita. "Hayley Lever, N.A., Caldwell, N.J." In *Art and Artists of New Jersey,* 86–88. Somerville, N.J.: C. P. Hoagland Co., 1938.

H. V. Allison Galleries. *Jane Peterson (1876–1965), Hayley Lever (1876–1958).* Exh. cat. New York: H. V. Allison Galleries, 1990.

Kempler, Cheryl. *Hayley Lever: Works in Various Media.* Exh cat. Wilmington, Del.: Delaware Art Museum, 1978.

Kennedy Galleries. *Hayley Lever, N.A. (1876–1958): Paintings and Watercolors.* Exh. cat. New York: Kennedy Galleries, 1965.

———. *Hayley Lever Watercolors.* Exh. cat. New York: Kennedy Galleries, 1983.

Macbeth Gallery. *Exhibition of Paintings by Hayley Lever.* Exh. cat. New York: Macbeth Gallery. 1920.

———. *Paintings by Frederick C. Frieseke and Hayley-Lever.* Exh. cat. New York: Macbeth Gallery, 1922.

———. *St. Ives by Hayley Lever, A.N.A.* Exh. cat. New York: Macbeth Gallery, 1928.

McCulloch, Alan. "Lever, Richard Hayley." In *Encyclopedia of Australian Art,* vol. 2, 692–93. Richmond, Victoria, Australia: Hutchinson, 1984.

Memorial Art Gallery. *Exhibition of Paintings by Mr. Hayley Lever of Cornwall, England.* Exh. cat. Rochester, N.Y.: Memorial Art Gallery, 1914.

——. *Catalogue of an Exhibition of Paintings and Etchings by Hayley Lever, Paintings by Leopoldo Mariotti and Etchings and Lithographs by Herbert Pullinger.* Exh. cat. Rochester, N.Y.: Memorial Art Gallery, 1921.

Montclair Art Museum. *Exhibition by Hayley Lever.* Exh. cat. Montclair, N.J.: Montclair Art Museum, 1930.

O'Gorman, James F. *This Other Gloucester: Occasional Papers on the Arts of Cape Ann, Massachusetts.* Reprint. ([Gloucester, Mass.]: Ten Pound Island Book Co., 1990).

Phillips, Duncan. *A Collection in the Making.* Washington, D.C.: Phillips Memorial Gallery, [1926].

Previti Gallery. *Hayley Lever: A Retrospective, Oils and Watercolors.* Exh. cat. New York: Previti Gallery, 1985.

Radford, Ron. *Our Country: Australian Federation Landscapes, 1900–1914.* Exh. cat. Adelaide: Art Gallery of South Australia, 2001.

Syracuse Museum of Fine Arts. *Catalogue of an Exhibition of Oil Paintings, Water-Colors and Prints by Hayley Lever.* Exh. cat. Syracuse, N.Y.: Syracuse Museum of Fine Arts, 1929.

——. *Catalogue of an Exhibition of Paintings and Etchings by Hayley Lever.* Exh. cat. Syracuse, N.Y.: Syracuse Museum of Fine Arts, 1921.

Toledo Museum of Art. *Catalogue: Paintings and Etchings by Hayley Lever, Paintings and Drawings by Henry I. Stickroth, Interior Decoration Exhibition.* Exh. cat. Toledo, Ohio: Toledo Museum of Art, 1921.

Watson, Forbes. *American Painting Today.* Washington, D.C.: American Federation of Arts, 1939.

White, Claire Nicolas. *Hayley Lever.* Exh. cat. New York: Graham Gallery, 1977.

Whybrow, Marion. *St. Ives, 1883–1993: Portrait of an Art Colony.* Woodbridge, Suffolk, Eng.: Antique Collectors' Club, 1994.

Articles

"Art: Exhibition of the Week." *New York Times*, 29 March 1925, sec. 8, p. 11.

C., L. "Hayley Lever." *Art News* 60 (September 1961): 16.

Caffin, Charles. "New and Important Things in Art: Remarkable Advance Shown in Hayley Lever's Recent Work." *New York American*, 19 March 1917, p. 7.

Cahill, Edgar Holger. "Hayley Lever, Individualist." *Shadowland* 7 (November 1922): 11, 77.

Canaday, John. "Hayley Lever." *New York Times*, 27 May 1967, sec. 1, page 8.

Ely, Catherine Beach. "The Modern Tendency in Lawson, Lever and Glackens." *Art in America* 10 (December 1921): 31–37.

Goodrich, Lloyd. "Exhibitions: the Milch Gallery." *Arts* 16 (30 June 1929): 265.

Green, Theodora. "Hayley Lever: An Australian Expatriate Painter." *Art & Australia* 27 (1989).

Gruen, John. "Hayley Lever: Selected Work, c. 1900–1933." *World Journal Tribune*, 28 April 1967.

"Hayley Lever, Joseph Szekely: Balzac Galleries." *Art News* 30 (26 December 1931): 10.

Ingram, Terry. "The Australians Who Painted America." *Airways Inflight* (January/February 1983): 28–37.

L., M. [M. Lansing]. "Hayley Lever and Joseph Szekely: Balzac Galleries." *Parnassus* 4 (January 1932): 13–14.

Moore, William. "Notes on Some Younger Australian Artists." *International Studio* 53 (September 1914): 202–10.

——. "The Public Art Galleries of Australia." *International Studio* 49 (May 1913): 202–12.

Nelson, W. H. de B. "The National Academy of Design: Winter Exhibition." *International Studio* 51 (February 1914): clxxxiv.

N., W. H. [W. H. de B. Nelson]. "A Painter of Harbours: Hayley Lever." *International Studio* 52 (May 1914): xcii–xciii.

"News of the Art World." *World* (New York), 20 December 1914, p. 3.

"News of the Art World." *World* (New York), 10 January 1915, p. 3.

"News and Comments in the World of Art: Dabo, Lever, Mas Olle and Bruce Exhibitions." *Sun* (New York), 25 March 1917, p. 12.

"Notes on Current Art: Hayley Lever's Pictures." *New York Times*, 28 March 1920, sec. 6, p. 20.

"Paris in Jersey Found in Home of Caldwell Artist." *Newark Evening News*, 14 August 1936.

"The Passing Shows." *Art News* 44 (15 November 1945): 29–30.

R., J. K. [Judith Kaye Reed]. "Exhibitions." *Art Digest* 20 (15 November 1945): 38.

"St. Ives in America." *St. Ives Times,* 19 September 1924, p. 10.

"Studio-Talk." *Studio* 55 (15 February 1912): 47.

T., S. [Sidney Tillim]. "New York Exhibitions: In the Galleries." *Arts Magazine* 36 (November 1961): 44.

Tyrell, Henry. "American Aquarellists—Homer to Marin." *International Studio* 74 (September 1921): xxviii–xxxvi.

White, Claire Nicolas. "Hayley Lever." *Arts* 51 (April 1977): 9.

Wright, Helen. "A Visit to Hayley Lever's Studio." *International Studio* 70 (May 1920): lxvii–lxx.

Index to Illustrations